Ian King's
WATERCOLOUR LANDSCAPE
TECHNIQUES

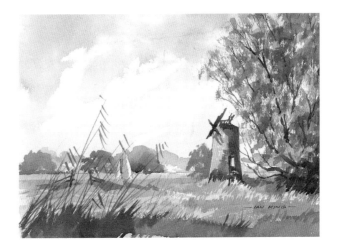

Dedication

I dedicate this book to the memory of Jocksie
for his constant help and support during the
years spent learning to paint.

Ian King's
WATERCOLOUR LANDSCAPE TECHNIQUES

Seven stages to success

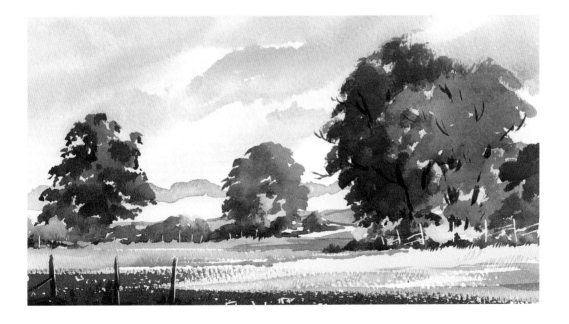

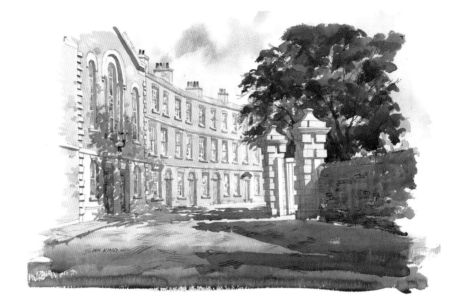

First published in 2003 by
Collins, an imprint of
HarperCollins*Publishers*
77-85 Fulham Palace Road
Hammersmith, London W6 8JB

The Collins website address is: www.collins.co.uk

Collins is a registered trademark of HarperCollins Publishers Limited.

04 06 07 05 03
2 4 6 5 3 1

Ian King would like to thank Roger Bunting of Anglia Television and Cathy Gosling
of HarperCollins for making this book happen. Special thanks to Heather Thomas for
providing the help and support this project needed.

Ian King asserts the moral right to be identified as the author of this work.

A catalogue record for this book is available from the British Library

Created by SP Creative Design
Editor: Heather Thomas; *designer*: Rolando Ugolini
Photographer: Charlie Colmer

ISBN 0 00 713745 1

Colour reproduction by Colourscan, Singapore
Printed and bound by Butler & Tanner Ltd, Frome and London

The following videos by Ian King can be obtained from Ian King Videos,
Anglia Television, Anglia House, Norwich NR1 3JG or www.angliatv.com:
Back to Basics with Ian King, Ian King's Watercolour Sketching Techniques and,
from the *King & Country* TV series, *Boats, Winter Light* and *Wind and Tide.*

Artwork reproduced by kind permission of Anglia Television:
pages 2, 9 (top), 56, 59 (top), 64, 66 (bottom), 70, 76 (top), 84, 103 (top)

Page 1: *Windmill on the Broads*; page 3: *Castle Rising, Norfolk*; page 4: *The Crescent, Wisbech*

Contents

Introduction

'Milk, butter, eggs. Have you paid?' This was Grandad's usual morning call as he took the old Morris van to visit the campers in his field. He had his use and vision of the Yorkshire Dales; we had ours. Both my parents were painters, so it was from a very early age that the Dales became regarded simply as a 'subject'.

The green pastures and dark peaty river beds were a splendid playground to many visitors, but to us they presented a different challenge – they were there to be painted. Childhood sorties into these landscapes were organized. We were armed with sketchbooks, pencils, paints and on-hand tuition but it was several years before I realized the real purpose of these engagements – they were to encourage us children to look and see.

In more recent years whilst tutoring painting around Britain and Europe, that same view has been endorsed hundreds of times, usually expressed as 'I've just realized that I've been wandering about blind for the last thirty years'. Painting does make you look; painting makes you see! It is developing the ability to see that brings as much pleasure as the actual craft of painting to most people who paint, and eventually it takes over your life.

▼ **Greta Bridge, Yorkshire**
38 x 56 cm (15 x 22 in)
This was painted in the style of John Sell Cotman. With their limited palette, the early watercolourists had to use the earth colours to create the light and depth.

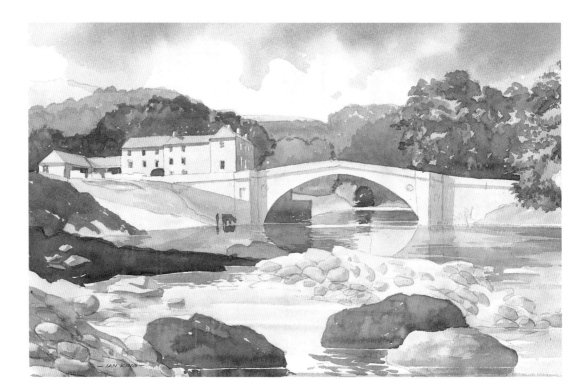

The Norwich School

Anyone painting watercolours today owes a huge dept to the pioneering watercolourists who became known as the Norwich School. As such, no school ever existed and it was more a meeting of minds and an exchange of ideas and techniques. Between 1790 and 1830, the geographic location for this artistic movement was Norwich, and hence the title we understand today. The Norwich School had a romantic approach to painting and it is this that makes watercolour painting what it is today. However, there was still a need to observe and draw. In fact, some members of the Norwich School were actually employed as drawing masters to the sons and daughters of the wealthy patrons

▲ Coverdale, Yorkshire
38 x 56 cm (15 x 22 in)
Using the same method as Cotman and the Norwich School but with additional modern pigments, the whole painting is brighter and the depth greater as we can use the earth colours to greater effect.

whom they had come from London to East Anglia to find. Perhaps the most famous of these painters was John Sell Cotman.

In his paintings you can see the use of transparent and opaque colours for backgrounds and foregrounds. In this fresh, simple approach, the brushwork achieves the maximum with the minimum. Although painted nearly 200 years ago, his works still look fresh and loose today.

7

The seven stages approach

In order to fully understand the methods of the Norwich School, I have evolved a unique stage-by-stage method which, over the years, has helped hundreds of aspiring watercolourists master the techniques of this style. There is no such thing as the correct method, but there are some basic simple rules that can help to give you an understanding of this very challenging medium, thereby creating brilliantly lit, evocative paintings easily and cheerily. This book contains all you need to know to achieve this in your own painting.

Watercolour painting has become a way of life to me. It has taken me to beautiful places and has always been stimulating, providing me with hours of pleasure and a career in fine art, teaching and television. You are about to become part of it. Welcome to the world of watercolour.

If Grandad could still lean on his gate, he might well be thinking: 'You know what, lad. You could probably make some money out of this.'

▶ **Horsey Mill, Norfolk**
29 x 41 cm (12 x 16 in)
Often walking around a subject can give you a better view as shown in this study of Horsey Mill.

▼ **Orwell Estuary, Suffolk**
15 x 45 cm (6 x 18 in)
A great subject on a soft, misty morning. The depth is created by using aerial perspective. Although there is an illusion of lots of detail, in fact there is virtually none. The best paintings work at this level.

- IAN KING -

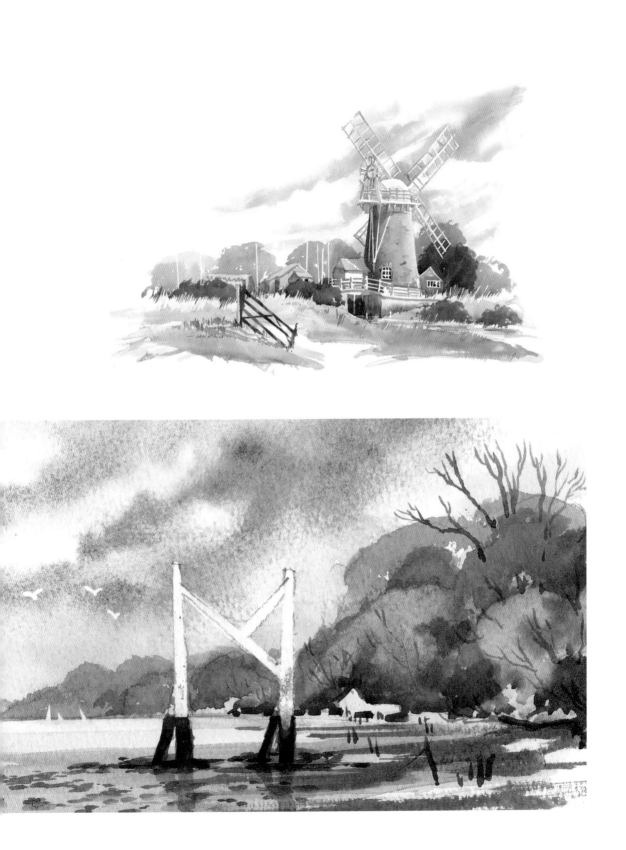

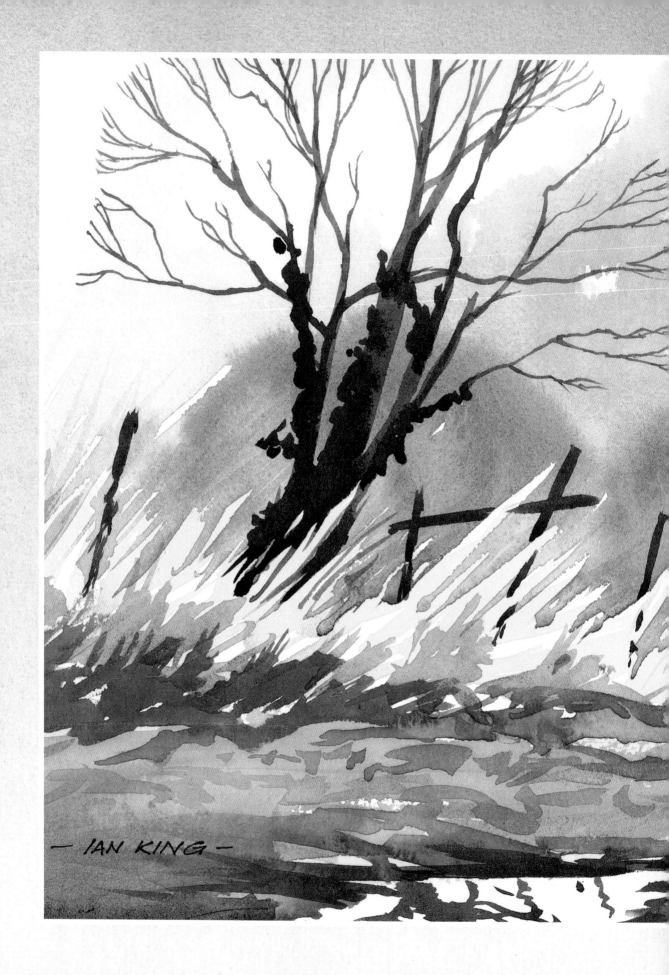

— IAN KING —

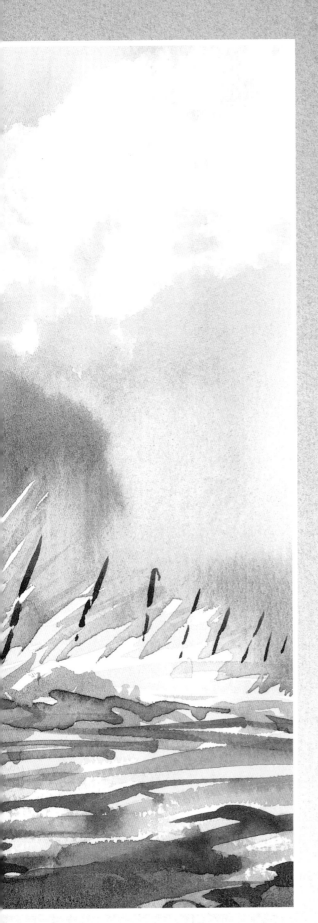

Getting into it

So having decided that you want to paint in watercolour, what's your next step? For many of us, it's probably a visit to our local art shop – an Aladdin's cave where we will spend hours of our precious time and lots of hard-earned money. I suggest that you read the next chapter before you start buying any art materials, but the best advice is always to keep them simple and buy only what you need. You must also master a few basic watercolour techniques, which are explained in detail in the following pages. Then you will be ready to start painting.

◀ **Winter Furrows**

18 x 23 cm (7 x 9 in)

As we shall see, often the simplest subjects make the best paintings. Using a soft wet in wet background technique with a more detailed foreground, the simple tree and headland here make a lovely fresh study.

Materials and Equipment

In order to paint successfully, you will need some essential items of equipment. The less equipment you start with, the easier the whole process will become. You will learn very quickly how to use your equipment and materials if you keep them simple. There is no point in buying a lot of expensive items that you may never use.

Paints

First of all, you will need some watercolour paints, which have been specially developed by artists working with manufacturers for over 200 years. Any old paint will simply not work. Your brush selection left over from model painting won't work either, and paper, other than that developed for watercolour, will have you tearing your hair out! The initial outlay on basic materials needed will probably surprise you, but you can't paint without the right equipment any more than you can play golf with a cricket bat.

Initially you will need about eight colours. Tube paints are the easiest to use and are cheaper than solid colours, which are really designed for use outdoors. There are two basic types:
• Students' colours
• Artists' colours
The difference is simply that students' colours are bulked out with extenders whereas artists' colours are virtually all pigment.

▶ *If you set your palette out as shown here, it will keep your colours clean. Never have reds and blues next to your earth colours – keep them well apart.*

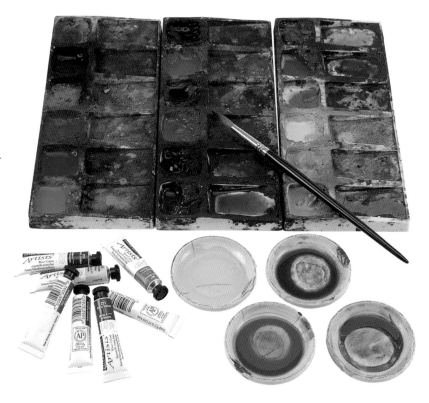

Raw Sienna
transparent yellow

Yellow Ochre
opaque yellow

Cadmium Yellow
opaque, warm yellow

Burnt Sienna
transparent red

Burnt Umber
transparent brown

French Ultramarine
transparent, warm blue

Prussian Blue
transparent, intense blue

Cobalt Blue
transparent, cool blue

▲ *As a beginner, you don't need to buy a lot of expensive paints. The eight colours shown here will be sufficient and can be mixed to create other colours.*

The students' range will cost you far less than the artists' colours, and virtually every art shop will stock these. To be honest, when you're starting out, these are more than adequate.

You will learn how to mix colours together, and how to apply washes. The colours you create with students' colours will not be as bright or as dark as artists' colours, but while you're learning this will not really matter. As you progress and colours begin to run out, replace them with the more expensive artists' colours. The initial outlay for a whole palette would be enormous but buying one or two at a time makes sense.

Earth colours (Raw Sienna, Yellow Ochre, Burnt Sienna and Burnt Umber) are better purchased in larger 14 ml tubes as you will use a lot of these. With other colours, such as Cadmium Yellow, a small 5 ml tube is sufficient. Paints often go hard in the tube before you ever get round to using them up, and they seem to last for years!

Beginner's palette

You will need some transparent colours and some opaque colours. The usual beginner's palette (see the illustration above) is the same as that of most landscape artists although they will add a few extra colours. The palette should always have some 'earth colours' as a base together with some blues, which are mixed with the earth colours to make your greens. You don't need blacks or whites. In most boxes of colours, there is usually a Chinese White. You don't need it – hand it in at your local police station now! The black you might want to keep, even though you will hardly ever use it.

Some other colours you might like to add to this basic palette include the following: Coeruleum, Hooker's Green, Payne's Grey, Alizarin Crimson and Neutral Tint. It is worth bearing in mind that the more colours you have on your palette, the more confusing the mixing will become. Mastering your mixing is the first real hurdle you need to cross in order to paint well.

Brushes

Unlike paints, your brush selection will be better if you invest in quality. There are thousands of brushes out there to buy. Just bear in mind that you only need about five, so it's worth spending that little bit more on them; they will do the job better and certainly last longer. Natural hair has barbs on it and it is these barbs that hold the paint, so the more natural hair the better even though they are more expensive than man-made fibres. Nylon brushes have smooth fibres and therefore do not work so well. However, most brush manufacturers now offer a range that are a mixture of natural hair and nylon fibres. These are less expensive than pure sable hair and, frankly, when you're starting out, they will do just as well. The exception is a large sky brush, which is usually made from squirrel hair.

Natural hair is a ready meal for moths, so you will need something to keep your brushes in. I use a bamboo mat which protects the delicate tips and lets them breathe. This is important; if you put brushes away wet and sealed up, they will soon become mouldy and will be ruined.

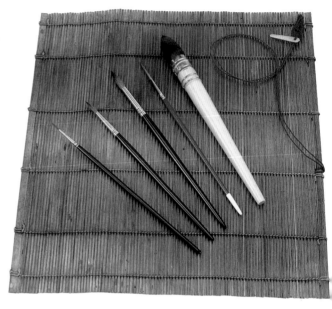

▲ A bamboo mat is ideal for keeping your brushes safe and protecting the tips. Always wash your brushes well after use and then allow them to dry thoroughly, tip upwards, before rolling them up in the mat. The brushes shown here are (from left to right): round brushes Nos. 2, 4 and 8, a rigger and a large squirrel mop brush.

Other materials

Apart from paints and brushes, there are several other items that you need, including masking fluid, waterproof ink, watersoluble pencils, artists' sponges, masking tape, some tissue (for blotting), drawing pencils and plastic erasers. All these items are worth purchasing together with a standard drawing board.

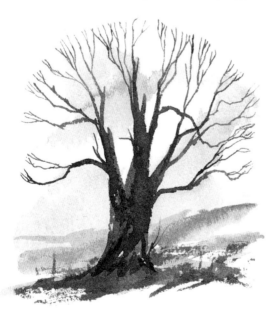

◀ Using different-sized brushes helps to create textures in a subject. Here the tree was painted with a No. 8 round brush, the branches with a rigger, and the background and foreground with a large mop.

Special equipment

After several weeks of painting, you will feel that you need some more equipment. Many of these items, you can easily make yourself. For example, a mahlstick is extremely useful when you are painting, and you can make your own from a macramé bead and a short length of dowel.

Art shops are very tempting, and there are always some items that it's better to buy than try to make yourself. If you're painting outside, a metal easel, a lightweight drawing board and collapsible water pots will come in handy. You may also need some large bulldog clips to stop the paper blowing away, plastic palettes, plastic knives and a fishing box to carry everything in.

Top tip

You may be surprised to discover that one of your most useful painting tools is a credit card. You can use one to etch out boulders and tree trunks (see page 21). For obvious reasons, it is best to use an old card for this.

▼ *Here are the extras I normally carry about in addition to my paints and brushes – sketchbooks, ink, pencils, masking tape, eraser, scalpel, rubber bands, drawing pins, a mahlstick and masking fluid.*

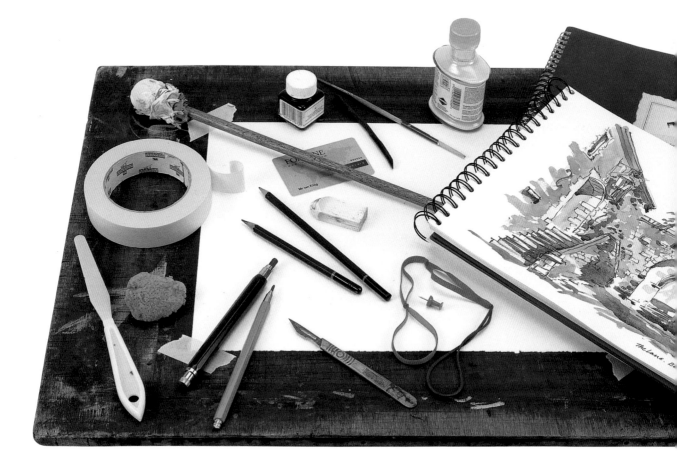

Paper

Choosing the right paper from the range that is available may confuse even the most experienced artist. As a beginner, you will need a wood pulp paper, but be certain that it is a watercolour paper. Many of the watercolour pads on sale are unsuitable, so make sure you ask specifically for watercolour paper. The most common one is Bockingford. This paper will do everything you expect of it, and is available with either a *not* or a *rough* surface (see right).

The weight of paper is actually its thickness. A good weight is 300 gsm or 140 lb. A less weighty paper than this is usually too thin to put a lot of water on and will cockle when paint is applied. Some of the heavier papers are difficult to use.

Paper surfaces

There are three basic paper surfaces to choose from, and these are as follows:

● **Hot pressed**: This is very smooth and good for ink and pen, but not for broken washes.

● **Not (or cold pressed)**: The surface is impressed, using a felt blanket. It's a better choice for painting subjects such as architecture and boats where you need to create straight edges. It's the ideal surface for beginners.

● **Rough**: This paper surface is impressed with a woollen blanket, and is usually the same on both sides; thus both sides can be used. This is great for landscapes and broken brushwork.

▼ *The brush strokes below illustrate the effects of different papers on watercolours.*

<table>
<tr><td align="center">

Not paper

</td><td align="center">

Rough paper

</td></tr>
<tr><td align="center">

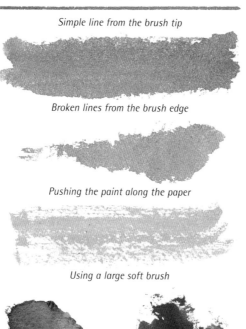

Simple line from the brush tip

Broken lines from the brush edge

Pushing the paint along the paper

Using a large soft brush

</td><td align="center">

Simple line from the brush tip

Broken lines from the brush edge

Pushing the paint along the paper

Using a large soft brush

</td></tr>
<tr><td align="center">

Adding colour to a Twists of the brush
pre-wetted area on the paper

</td><td align="center">

Adding colour to a Twists of the brush
pre-wetted area on the paper

</td></tr>
</table>

Different papers

You will gradually learn and understand more about papers as you progress through this book, but remember that there are no savings with cheap paper; it simply does not work. When you have begun to master the basic techniques, you may wish to experiment with different papers. I have suggested this to many painters on courses. Changing your paper will always alter the appearance of your work. You will find that while some papers suit your style, others won't. Wood pulp papers are the simplest ones to use, basically because you can easily lift out any part you like. With a cotton paper, you cannot lift out, although the paints will always look brighter, and wet in wet techniques will be more effective because cotton absorbs water better.

Top tip

You won't need to stretch the paper; simply cut it to size and attach it to a board with a piece of masking tape at each corner. Stretching paper is a poor use of your valuable painting time and can ruin many papers. Personally, I always paint on 140 lb weight paper and never stretch it first, as it expands when water is applied. I simply keep pulling it tight at each corner; it never fails me.

▼ *The best possible way to spend a day is painting 'en plein air'. Here's the author in his element.*

Watercolour Techniques

As you will learn, good painting requires good control of water, colour and brushwork. Your colour is your alphabet while your brushwork becomes your language. With practice, you can create all the effects you need. Judging how much colour, how much water and which brush to use are the first hurdles for you to jump, so it's fasten your seat belt and off you go!

Mixing a basic wash

When you start mixing washes, you should always begin with a clean area of your palette. With a No. 8 round brush, add some clean water, about a teaspoonful, to your palette. Then dip your No. 4 round brush into the French Ultramarine paint until about half of the brush is covered in paint. Add this to the water in the palette and mix well together. You have now made your first simple wash, which is the basis of all watercolour. The golden rule is never to put the paint in first; this will simply waste paint and make the water dirty.

Using your No. 8 brush, paint a small area of the watercolour paper. Try to get this even without overbrushing it too much. Overbrushing will make your colours look dirty by disturbing the surface of the paper. Add about the same amount of water again, mix well and paint a new area. When this dries, you will see that the first is darker than the second. This is why we do not use white to make colours lighter; we simply add more water to them. Add some more water and you will see that the wash is paler still. It is difficult to judge just how dark the wash needs to be, especially when any blues have been added as blues always dry lighter than they appear when wet.

1 *With a No. 8 brush, you should first paint a wash of French Ultramarine.*

2 *Add more water to it. Let them dry flat and see how much lighter the second wash is.*

3 *Now add even more water, tilt the board and leave to dry. This will dry smooth with no granulation.*

You will see that the first two colours shown have a dimpled pattern – granulation. It occurs when the pigment, a mineral, settles into the hollows in the paper. This technique can be used to create interest in washes. When you don't want granulation, simply tilt your board to a more vertical angle and the wash will dry smooth.

Mixing a two-colour wash

Try this basic wash again, using Raw Sienna. You will see that blues change more than the earth colours. Try mixing French Ultramarine with Raw

Sienna, then paint another area. Do the same again with French Ultramarine and Yellow Ochre. The mix with Yellow Ochre will appear more solid than the mix with the Sienna. This is because the Sienna is transparent and the Ochre is opaque. This is one of the most important washes to work at. If there is no difference between these washes when they dry, you are adding either too much or not enough water. The wash should not be thick; it should be very wet. These two greens are the most important ones you'll ever use. They are the basic landscape greens.

1 *Paint a wash of Raw Sienna.*

2 *Now add some water and watch it dry.*

1 *Paint a transparent wash of Raw Sienna and French Ultramarine.*

2 *Now paint an opaque wash of Yellow Ochre and French Ultramarine.*

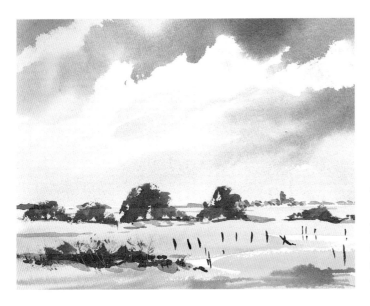

◀ **East Anglian Landscape**
17 x 23 cm (7 x 9 in)
The distant greens in the background are Raw Sienna based (transparent) whereas the foreground greens are Yellow Ochre based (opaque).

Wet and damp washes

Having got the hang of mixing washes of the same strengths, we can now move on to using wet washes with damp washes. This useful technique is needed for creating subtle changes in colour. However, you should always remember the following guidelines.
• A brush loaded with water makes a wet wash.
• A brush with the excess water shaken out of it makes a damp wash.

Make a wash and paint a small area, then paint a different coloured wash next to it and see what happens. This is one of the many mixing techniques that make watercolours so fascinating. You never know what will happen.

1 First of all, paint an area of Burnt Sienna.

2 Next to the Burnt Sienna, paint a damp wash of Prussian Blue. Leave the board flat and see how the colours run and mix together.

3 Paint an area with a very wet French Ultramarine wash, then add a thicker mix of Burnt Umber to the base. Hold upright and watch the top spread into the wet wash and the bottom dry with a hard edge. It looks like distant winter trees.

Reservoir technique

This technique produces subtle changes in the same colour; it's great for painting roofs, walls and solid areas in order to create extra interest in your paintings.

A fairly strong colour wash is washed onto the paper and then teased around using a damp brush. This will make the wash have varied depths and strengths. You will see how some of the wash will dry lighter where more water is added. You can practise this as much as you like; mastering this technique will greatly enhance any watercolour you paint. Next try one very wet wash with a drier wash added as shown in the illustration (bottom).

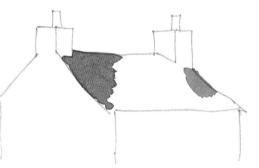

1 The colour is washed on quite strongly in a couple of small areas, usually to show edges or corners.

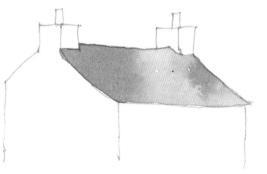

2 Whilst still wet, the colour is washed out and spread using a brush with clean water. The effect created will give you a random depth of colour, ideal for walls and roofs.

Etching

You may wonder why brushes have a pointed handle. This is for etching wet paint. Creating lines from the original colour always looks better than something drawn in later with a pencil or pen.

▲ *Planking on boats and timber buildings always looks good done this way. Paint the base colour and then etch in the lines with a brush handle.*

▲ *A little dark brown was added whilst still wet so it ran into the Raw Sienna. Grasses and pebbles were etched in with a brush handle. Looks great, doesn't it?*

Dry brush technique

A foreground can look wonderful with a broken wash laid over a solid area of colour.

▲ *This interesting effect was achieved by using a nearly dry mop brush and painting the strokes in one direction only; otherwise the gaps begin to fill in.*

Credit card technique

This is not actually a new technique; the early watercolourists used a specially trimmed thumb nail or a thin piece of ivory instead of a credit card. The wet paint is simply removed with the edge of the card to leave areas of white paper. The results are visually more exciting than those achieved with masking techniques.

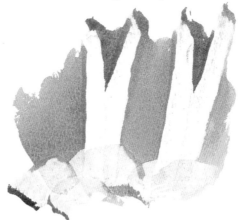

1 *Wash in a large area of colour as a background. Quickly scrape out some white areas before the paint dries, using the card like a window cleaner uses his squeegee. This works best on wood pulp paper.*

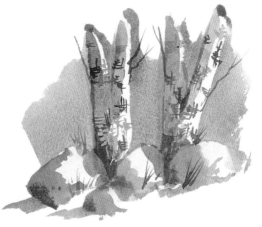

2 *When the first wash is dry, add the details. Here I turned the tree shapes into Silver Birch, using Burnt Sienna and Burnt Umber with a rigger for the bark. A few grasses were added using a rigger.*

Lifting out

Lifting out paint with some tissue and a sponge will create a different effect to using a credit card, but only works well on wood pulp based papers, the most commonly available being Bockingford.

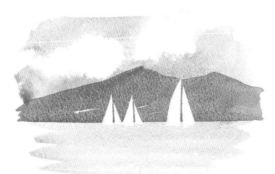

▲ *The sky and water were painted with French Ultramarine and the clouds blotted out with a tissue whilst wet. When dry, mountains were added with Raw Sienna and French Ultramarine and left to dry. A stencil of sail shapes was cut out of paper and, using a damp sponge, the sails were lifted out.*

▲ *A solid area of colour can be shaped by blotting part of it with a wet sponge to lighten the colour. I masked this chimney stack with tape, sponged out until the area was light enough, then removed the tape and, hey presto, a three-dimensional chimney stack appeared. Be careful removing the tape or it will pull the paper up.*

Masking fluid technique

Masking fluid enables us to paint freely but keep our details, either by leaving some white paper or retaining colour. Mask the details with latex fluid, applying it with an old brush or cocktail stick.

1 *The reeds were painted as a solid area; when dry, they were put in with masking fluid.*

2 *When a dark wash was added, the masked areas resisted the paint and appeared light.*

Candle wax technique

Wax works in the same way to resist the paint, but it is more random and can't be removed. It is usually used for creating ripples in water. Don't overdo it as it can never be painted over.

▲ *The wax can be drawn on in straight lines or added as scallops for running water. Keep it level or the water will look as if it's going uphill! Add the paint on top.*

Brushwork

Every brush will create a different mark when you use it. How you hold the brush will add to the range of marks that you can make with it. Brushwork is the language of all painters – the colours and the paper are only the mediums we use. The marks that we make with our brushes determine our level of creativity and, once mastered, our own personal style of painting. And the more often you paint, the better your brushwork will become.

Using the brush on its tip

The way in which you hold your brush can also change the strokes. You can see from the brush strokes below, the marks that the suggested brush range will make when held conventionally and painting with the tip. See how long a line you can make with a rigger compared to a No. 2 round. From one dip into the paint with a rigger, you can create long, long lines, especially for ropes and rigging. The other brushes make lines of varying thicknesses. For instance, a No. 4 mop is good for painting skies but of little use for fence posts.

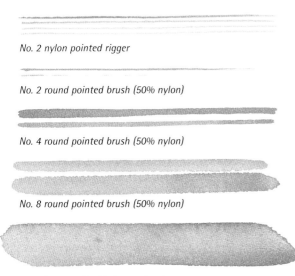

No. 2 nylon pointed rigger

No. 2 round pointed brush (50% nylon)

No. 4 round pointed brush (50% nylon)

No. 8 round pointed brush (50% nylon)

No. 4 large squirrel hair mop brush

Using the brush on its side

Using the same brushes on their side, you get a completely different set of marks. The rigger is not included as it can only be used with its tip. With the smaller round brushes, you get rougher edges and gaps appear in the painted stroke. As the brushes get larger they hold more paint so the marks are longer before breaking up. The No. 4 mop hardly breaks up at all when it's full with paint, and this is why it's great for skies.

No. 2 round pointed brush (50% nylon)

No. 4 round pointed brush (50% nylon)

No. 8 round pointed brush (50% nylon)

No. 4 large squirrel hair mop brush

Using a rigger

When you have delicate areas to paint, such as twigs on winter trees, a rigger can create flowing lines. A normal brush would need refilling with paint after a second or two, the lines becoming thick and then thinning all the time, and the effect would be spoilt.

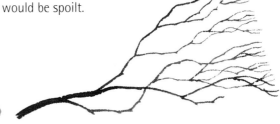

Mixing colours

Having mastered mixing washes and the art of brushwork, your next challenge is colour mixing. Making a simple colour chart will help you to learn your colours – and remember which ones you need. This takes a couple of hours but is time well spent. Until you know your colours, any painting you try to do will be at best a lucky accident.

The colour chart illustrated below is created by mixing equal amounts of the colours on the chart. By adding your original colour palette to the chart, you will quickly recognize any colour.

1 Start with Raw Sienna and paint the first square on the top line.

2 Now mix a little French Ultramarine and paint the first square on the second line to the left.

3 Mix these two together and then paint the second square from the left on the second line.

4 Clean up, then add a square of Prussian Blue to the third line down.

5 Mix with the Raw Sienna to create the next square in, and so on.

Cleaning up each time will probably seem a bit wasteful but you need this chart to have clean colours if it is to be any good later. When you have completed the chart, you will see that the colours made with the Siennas are lighter looking than those made with either the Ochre or the Umber. This is because the Siennas are transparent colours.

You will also now have a complete guide to the range of greens that can be made from the Earth Palette. This little chart is invaluable.

▼ *It's amazing how many colours can be created from just a few. Cover this chart in plastic to make it a permanent aid. It will become your best friend.*

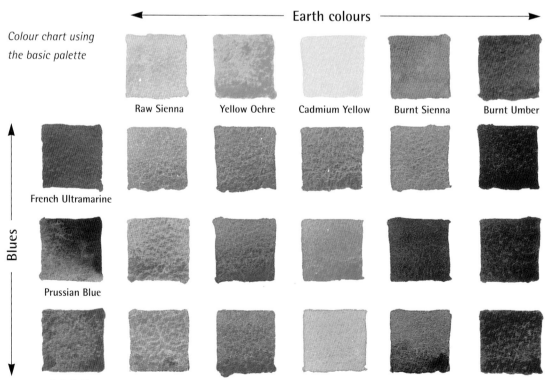

Colour chart using the basic palette

Earth colours

| Raw Sienna | Yellow Ochre | Cadmium Yellow | Burnt Sienna | Burnt Umber |

French Ultramarine

Blues

Prussian Blue

Cobalt Blue

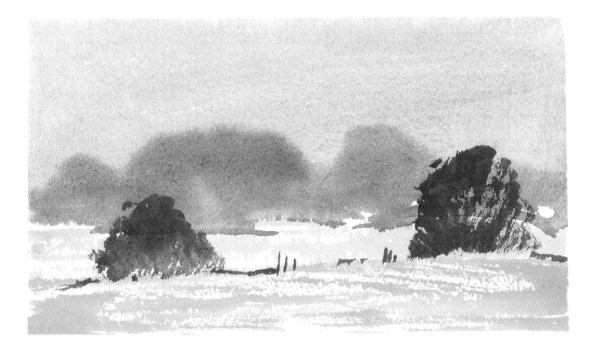

Try a little exercise

By now, having learnt about mixing basic washes and brushwork, you should feel that you are ready to paint something, so here is an easy little exercise which will help you to put it all together and get you going. You can use the picture above as your guide.

First of all, you must decide how large a piece of paper you need for your painting. Controlling your brushwork and washes will be easier if you think small. I usually suggest something a touch larger than a postcard.

1 Tape the paper down on your drawing board with a few strips of masking tape.
2 Mix a wash of pale French Ultramarine, using a large No. 8 brush.
3 Now paint this wash over the top two-thirds of the paper.
4 Whilst this is still wet, paint a little Burnt Umber into it, using a No. 4 brush. Hold the drawing board up vertically and let the paint dry.

▲ Simple Landscape

12 x 22 cm (5 x 9 in)
You can use your earth colours and blues to create a simple little landscape. You could try using the same technique to create several of these natural scenes. Experiment with varying the trees and maybe adding a barn but keep them small.

5 Using the edge of a No. 8 brush, add a stripe of Raw Sienna across the painting underneath the blue and the Burnt Umber. Allow to dry.
6 When this is completely dry, add a wash of Yellow Ochre underneath.
7 Finally, mix a wash of Yellow Ochre with French Ultramarine and, using the edge of a No. 4 brush, blob in a few trees.

Congratulations! You have just painted your first landscape. In the following chapters, we will look in more detail at how to plan your paintings, using my simple seven-stage system, and thereby add dimension and distance to them.

Sketching and Planning

A sketchbook has always been the life blood of all painters. Keeping one not only helps you to record what you see but it also helps you to learn to observe. Draw whenever you can – anything at all, it does not have to be grand. Don't feel embarrassed by your drawings – they're for your eyes only and you don't have to show them to anyone!

Keeping a sketchbook

Try to vary your sketches by using pens as well as pencils. With good-quality paper you can even incorporate a little colour. Record anything and everything. You will soon have a collection of sketches that you can feel proud of, and these can become the basis for many paintings with the use of your local photocopy shop!

It may seem wasteful but draw on only one side of the pages in your sketchbook; otherwise any pencil sketches will be transferred with pressure over the preceding pages and your work will get ruined. However, if all your sketches are in ink, this will not be a problem.

▼ **Valley Farm, Suffolk**

This subject is all about the angles and lines of the roofs. A pencil enabled me to show their texture far better than ink or pen could have done.

Top tip

To avoid running out of paper, with a pencil, draw a small page in the centre of your sketchbook page. Sketch in this initially and when your sketch grows out of your box, you can let it grow in any direction.

Pens and pencils

For drawing in your sketchbook I recommend a 3B pencil which will enable you to make fine lines or dark areas easily. However, keep it sharp; you can't draw with a jam spreader! There are many pens to choose from. I usually use a 0.5 mm tip pen with watersoluble ink. This can be washed over with water to create greys and tone.

Enlarging sketches

Lots of different ideas are circulated about making sketches larger and how best to transfer them to watercolour paper, using grids and a variety of other methods. All I can say is that the advent of a photocopy shop in virtually every high street has made it so easy. Your sketch can be enlarged to any size you like, and it need not be taken out of your sketchbook. Then, by fixing it to a window at home with masking tape, placing some watercolour paper over it and taping it down, you

can trace it straight through. Although watercolour paper looks opaque, it isn't. You can see straight through it, unless you are wearing something light which reflects light back from you.

The same applies when you are working outside. Use the car windows, especially a tailgate. It's great when you've made a drawing but the painting has failed. If this happens, you can draw it all again in minutes.

▼ **Watendlath, Cumbria**
38 x 56 cm (15 x 22 in)
This was painted in the studio from the sketch (right). Simply by having been there and making the sketch I had a feel for the subject even months later.

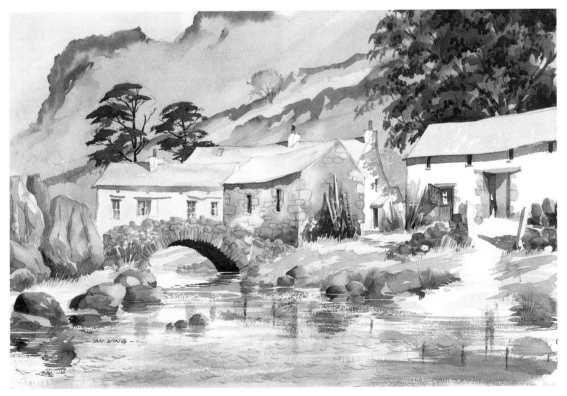

Perspective

In any painting or sketch, the perspective will alter according to your eye level. The viewpoint is the position from which you look at a scene, whether it's a landscape or a building. Thus, the perspective will change depending on your position and whether you are higher or lower than what you are looking at, as seen in the illustrations below.

Obviously, the nearer that objects are to you, the larger they will be, and the further away they are, the smaller they become. The vanishing point is where the perspective lines meet.

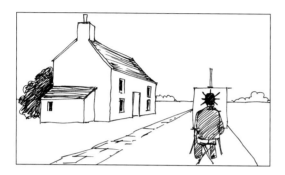

▲ *Your viewpoint is always at your eye level and the position in which you are sitting.*

▼ Moorland Farm

In this simple painting of a moorland farm, the perspective lines all converge at the vanishing point.

▶ Normal view
On level ground, the horizon is at eye level, halfway up the building.

▶ Manhole view
When looking up at the house, the eye level and vanishing point on the horizon are at floor height.

▶ Bird's eye view
When looking down on the house, the vanishing point and eye level are much higher.

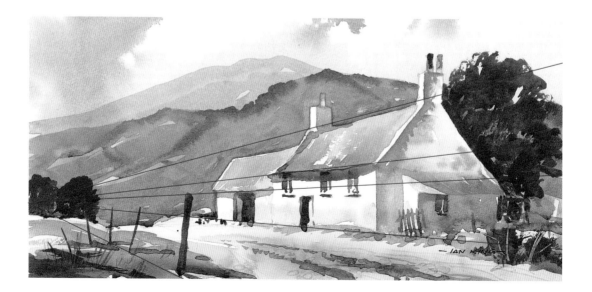

Planning it out

Before you start painting, draw the buildings on an odd piece of paper to be certain that the perspective will work. Many beginners find the whole concept of perspective confusing at first, but this method has had many a standing ovation on my courses. Just follow the simple guidelines below.

Fixed point perspective

All you need for this is a sharp pencil, a drawing pin and some elastic bands tied together.
1 At eye level, draw a line faintly across the painting and mark the spot in front of you.
2 Draw in the end of the first building. Put a pin in the spot in front of you and, with the elastic bands tied together, mark in the lines of the gutter, roof and base. The windows and doors can be shown by first drawing the front upright.
3 Using the elastic bands, draw in the tops and bottoms. All the vertical lines stay vertical.
4 Now that the first building is in perspective, do the same for the remaining buildings, including those on the other side of the street.

Top tip

The holes that you make in the paper will almost disappear after it has been wetted. Perspective was never easier than this!

Going round the bend

Fixed point perspective works well for a straight street. However, if the street has a bend in it, don't worry – just do the following and your perspective will always work.
1 Simply move the drawing pin along your line an inch or so for each building. You will soon see that the row of buildings then appears to go 'round the bend'.
2 On the sketch below you can see how the drawing pin has been moved by the stars that I have added to the paper to mark each spot. You can make your buildings go from left or right, up or down, by using the same method. It could not be simpler.

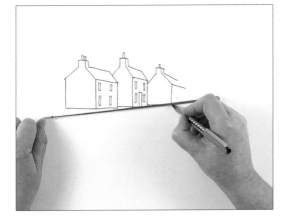

▲ *After constructing the basic guide lines, simply by drawing the facing wall of each building, the elastic band will do the work for you.*

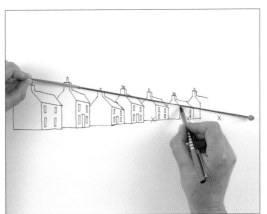

▲ *Where you need to go round the bend, simply move the pin to left or right for each building. The more the pin is moved, the greater the effect of the turn.*

Working from photographs

If you need to work from photographs, always make a sketch first. This can be enlarged (see page 27) and can then be transferred to your watercolour paper. Not only will it enable you to find your focal plane more easily (see page 34) but it will also ensure that your watercolour is a real painting and not just a copy of a picture. You can still think about it as your original. The worst thing that anyone can say about your paintings, however well-meaning, is that 'they are just like photographs'; then you know that you have failed gloriously.

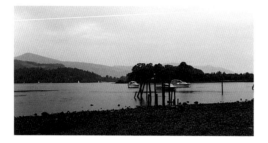

▼ **The Buttertubs, Derwent Water, Cumbria**
38 x 56 cm (15 x 22 in)
This painting has a very light background, a dark middle ground and a strong foreground with the posts left light against the dark trees.

▼ *A simple line drawing helps you understand the elements of the painting and where your background, foreground and middle distance are. It takes only a few minutes to do and can save you hours!*

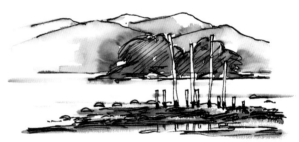

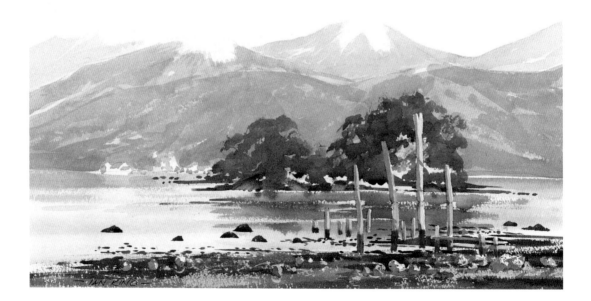

Learning to look

When you are outside looking at a view, your angle of vision is probably nearly 100 degrees. There will be so much potential subject matter that you won't know where to start. However, look closely at the subject. What attracted you to it? Try to determine this first as it will help you to plan out your painting. Many beginners complain that they don't know what to paint, but there is a subject everywhere, and your problem is deciding what to put in and what to leave out.

Top tip

As artists, we've all got a JCB in our back pockets. Unlike photographers, we can move or demolish anything. Your judgement will improve with time but, as a general rule, if a building, tree or object isn't going to do any work in your sketch, then leave it out.

▶ **Woodbridge, Suffolk**

Some subjects require an accurate sketch as of these boats against a jetty. A waterproof ink pen is ideal for this type of fine line work.

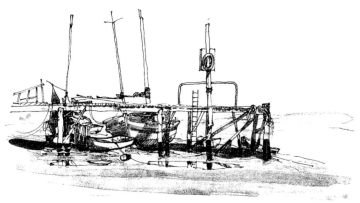

▼ **Watendlath, Cumbria**

I used an ink pen, adding some textures to show the detail in the foreground. I kept the backgound very simple and light. The darker areas were added with a brush pen.

Planning your painting

When planning a painting, always start with your 'subject'. Have a look round. Is there anything in the background that would look good behind the subject – a few trees or a distant hill? They don't have to be there for you to put them in. Borrow them and do the same for the foreground.

You may wish to leave out anything modern if you want your painting to look timeless. Cars and telephone boxes may be there but seldom add anything to your sketches or watercolours.

Once you have planned the background, subject and foreground, make a sketch. You may need to write down a few ideas and notes about colours, the date and time of day. You could also take a photograph for future reference.

When composing a painting, the classic 'rule of thirds' helps you achieve the right balance as well as making it look more dynamic. Don't place the subject right in the middle; this will look boring. Position it a third of the way in or a third of the way up – somewhere slightly off centre. Place buildings, mountains, the horizon, trees or foreground posts either a third of the way in from left or right, or from the bottom or top. The example opposite shows how the rule of thirds can be used to maximize a painting.

▼ **Haywain Tearoom, Flatford**
28 x 38 cm (11 x 15 in)
At first glance, this tearoom seems central but the background and foreground have been altered to make the thirds rule work.

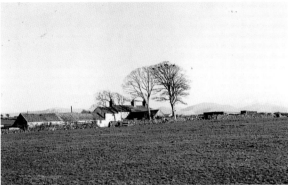

◀ *In this photograph of an Anglesey farm, the mountains of Snowdonia are in the distance.*

▼ *In my sketch, I have enlarged the mountains and moved the farm to the right so that the trees are a third of the way in from the right. The red line shows the focal plane.*

▼ **Farm at Pentraeth, Anglesey**
38 x 40 cm (15 x 16 in)
In the finished picture, a foreground has been created from a plain field by adding a path to lead the eye into the painting. A post or two adds extra dimension.

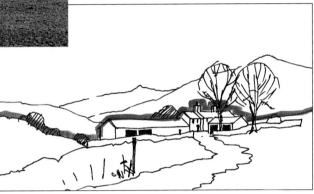

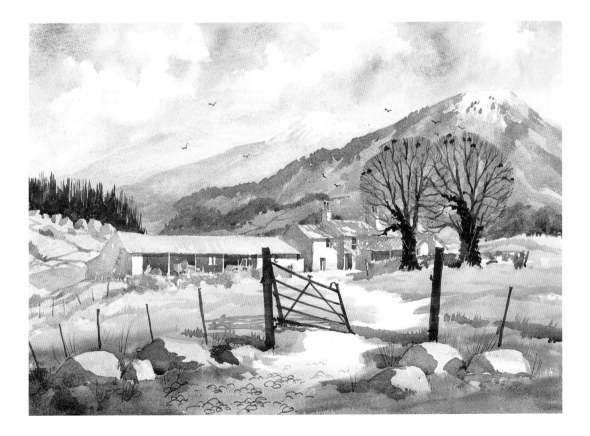

The focal plane

When you are planning your painting, do a quick sketch to help you find the focal plane. You can divide your painting into three planes:

1 The background, or furthest plane.

2 The middle distance, which is closer to you.

3 The foreground, which is nearest to you.

Your subject will nearly always be placed in the middle distance. Behind is the background where objects will diminish in size and will be painted transparently. In front is the foreground, where any objects will be larger as they are closer to you, and this is usually painted opaquely.

A horizontal line drawn across your painting over your subject is referred to as the focal plane. This is the dividing line between the background and foreground and anything above it will be furthest away from you and therefore smaller and more transparent.

This is the key to painting successfully in the style of the Norwich School. The focal plane determines where your sky is painted down to and where you will use Raw Sienna or Yellow Ochre in mixing your colours.

Everything works around the focal plane in your painting so it is worth taking a little time to be sure that you understand how to find it.

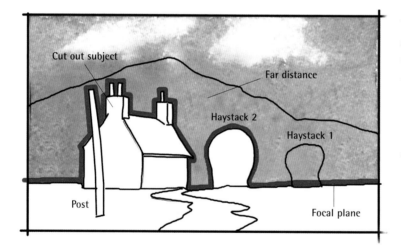

◀ Everything behind the focal plane, except clouds, will have a blue wash painted over it to help it recede. Haystack 1 is washed with blue but haystack 2 (in front of the focal plane) is left white as is the subject and any light areas in the foreground.

▶ As the foreground and background are painted, you can see how a sense of balance and depth begins to work. Paint the background transparently, usually over the sky wash, and the foreground opaquely. The focal plane is always where the transparency begins.

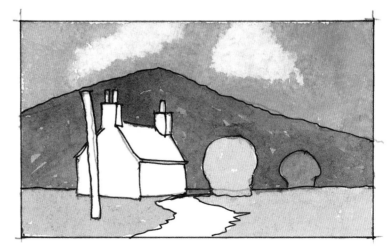

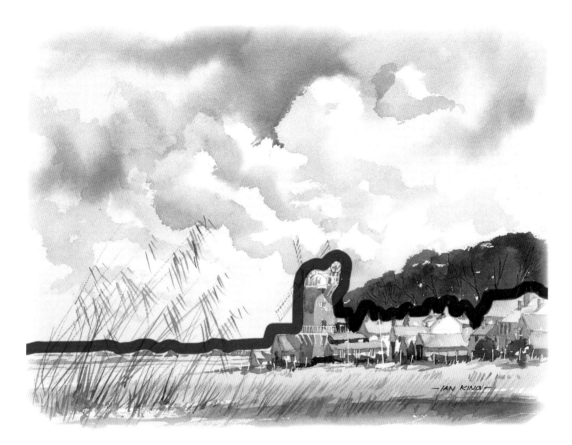

▲ Cley Mill, Norfolk

The focal plane is easy to distinguish here. It comes across the marsh level with the mill, behind the mill and cottages and in front of the background trees.

▼ Seven Sisters, Sussex

This working drawing shows how the focal plane separates the background from the foreground.

▲ Norfolk Autumn Fields

The focal plane is less obvious here but if you plan to have opaque trees in the foreground and transparent trees in the distance, it will cross the painting at the end of the opaque trees.

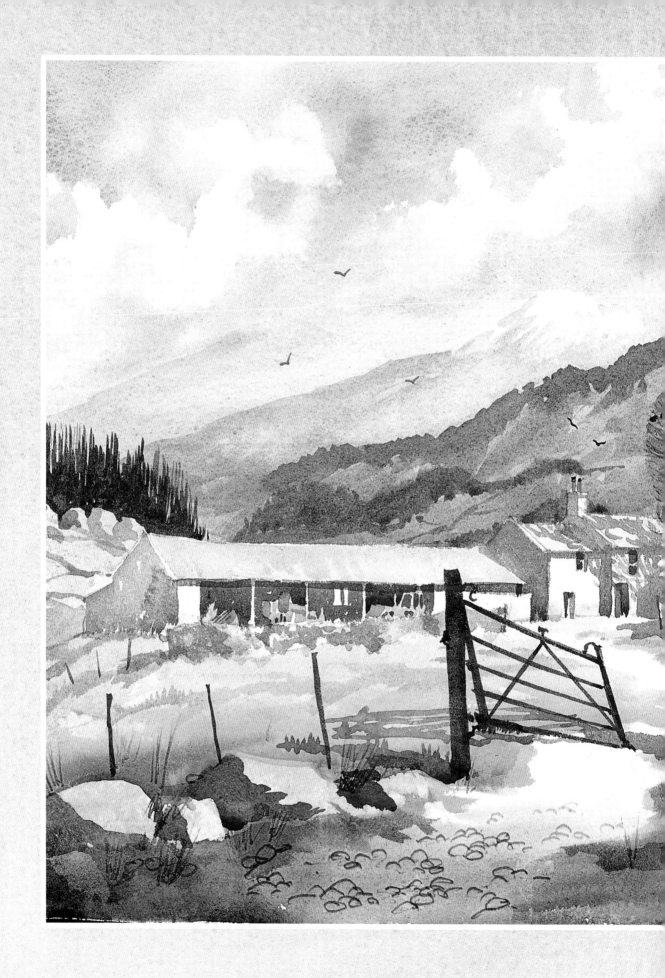

The seven stages

To paint successfully, you need to understand the subject. I have evolved a seven-stage system which will help you to master the processes for painting effectively. We start with an overview of a typical landscape and then break it down into the seven individual stages in step-by-step detail. We then take a broader view of each stage. By gaining an overall view of the whole subject before you start, it not only makes the process easier but also takes the terror out of it, helping you to focus on your subject, colour and technique. You will also find that this unique system, in the tradition of the greatest watercolour painters, enables you to work with both transparent and opaque colour, creating brilliant, fresh-looking watercolours.

◄ **Farm at Pentraeth, Anglesey**
38 x 40 cm (15 x 16 in)
There is a subject everywhere, even though sometimes you may need to re-structure it to make it work better. This painting is a classic example of what can be achieved with a simple subject. You are the artist – it is up to you to make it work!

The Basic Stages

Here is an overview of the seven stages of landscape painting. Each stage is examined in detail in the following pages as I show you, step by step, how to build up your painting.

Palette:

| Raw Sienna | Yellow Ochre | Naples Yellow | Burnt Sienna | Burnt Umber | Alizarin Crimson | French Ultramarine | Prussian Blue | Cobalt Blue | Coeruleum |

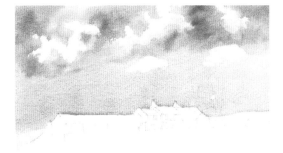

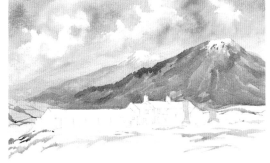

▲ Stage 1: the sky

Bringing the sky down to the focal plane gives everything in the background a blue base, making it recede automatically. The clouds and snowy peaks are blotted out with some tissue before adding the darker elements in the sky.

▲ Stage 2: the background

Layers of transparent hills are painted over the blue base to create depth. The more detailed mountain has stronger colours added to imply rocky outcrops. These colours are also added to the foreground for the light and dark bands.

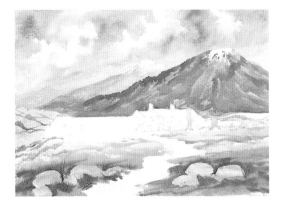

◄ Stage 3: the foreground

Transparent washes are added, first with an opaque wash in the foreground. Details are added, using a credit card and also by etching with a brush handle, before the dark greens are added wet in wet.

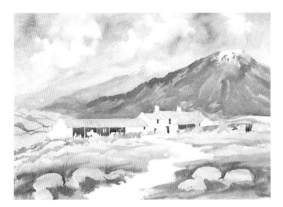

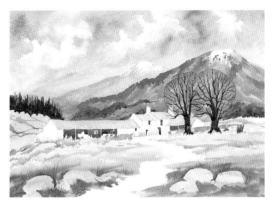

▲ Stage 4: the main subject

Many beginners make the mistake of starting with the subject but this always makes painting the background difficult. By painting the subject at this stage, it will not be necessary to add as much detail as we may have thought – less is often better in painting. Simple darks added at this stage begin to describe the entire subject.

▲ Stage 5: the trees

These are always better if they are painted before the details are added. Often a lot of the detail that we might have thought about including becomes unnecessary after the trees have been painted. The trees are also the tool we use to increase the sense of depth in our paintings. Positioning them is important.

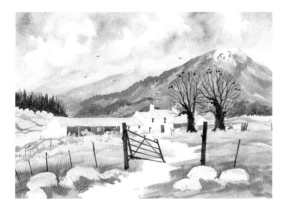

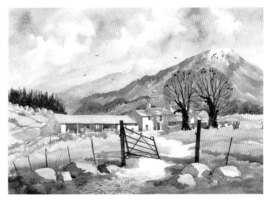

▲ Stage 6: the details

'If in doubt, leave it out.' When adding details, it is important that each one adds something to the painting. If it doesn't, it is best to leave it out. A great many paintings are ruined at this stage by over embellishment.

▲ Stage 7: the shadows

This is the final stage where the action takes place. Until the shadows go in, the watercolour will look quite flat and unlit. However, shadows can transform a study, making it sunny and three-dimensional.

Stage 1 : The sky

Before starting to paint, fix your chosen size of paper to your board (as described on page 17). You will not manage a subject like this well if you cannot turn your paper round. Also, get ready everything that you will need, including paints, brushes, palette and some tissue for blotting. Lastly, make sure that your brushes are clean.

▶ **Planning stage**

Before reaching for your paints, make a quick sketch of what you want to include. You can enhance the background and create a foreground path to lead the eye into the painting. You must also determined where your focal plane will be – shown by the red line. Behind it will be transparent colour; in front, it'll be mostly opaque. This shows where the sky wash will come down to.

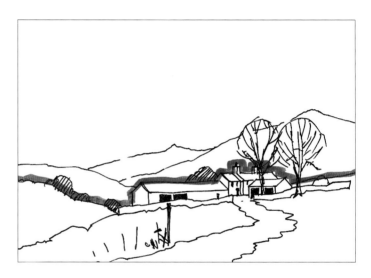

◀ **Stage 1**

Mix a wash of Cobalt Blue and a deeper wash of French Ultramarine – you will need quite a lot as you have a large area to paint. Turn the painting upside down; it is always easier to paint a sky from this angle, as you will learn as we go along. Wet the sky area from the focal plane to the top, carefully taking the edge over the buildings. Paint the entire sky with Cobalt Blue, using a large mop.

▶ Stage 2

Turn your painting the right way up so that you can see the shapes of the clouds. Blot out the cloud and snow shapes with some tissue. You will now have dry and wet areas in your sky. Into the top wet areas, add some French Ultramarine, using a No. 8 brush, not your mop, and work the blue in to the sky. Create new edges for the clouds, if wished.

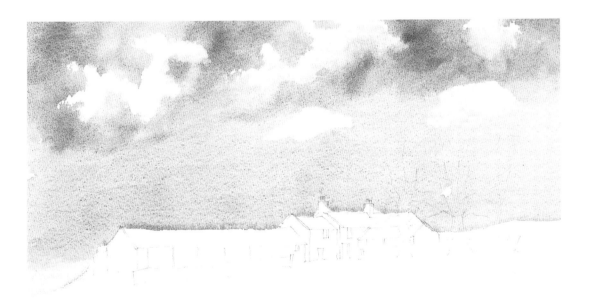

▲ Stage 3

Add the shadows to the underside of the clouds, using a mixture of Burnt Umber and French Ultramarine. You need to use a fairly large brush for this – a No. 8 is probably the best one. Wash the colour along the underside and left-hand sides of the clouds, teasing it up into the centre of the clouds with a damp brush. You will still be able to blot the middle area light again with some tissue if this should go wrong. Take your time when getting the colour to spread out evenly – there's no hurry.

Stage 2: The background

Good painting is all about planning, and it is well worth taking the time to plan each stage of your painting. Before creating the background, think about what you want it to look like. The mountains will look exactly as you make them, and there are four separate stages involved in creating them.

▶ Stage 1

As the mountains come forward, their colour gets deeper and this is built up layer upon layer. Mix Raw Sienna and French Ultramarine and, with a mop, wash in all three mountain shapes, leaving the snow unpainted. Lightly swipe out the misty effect between the two last mountains with tissue. Be gentle or you may remove the sky. Dry, then add a little of the same colour to the two large tree trunks.

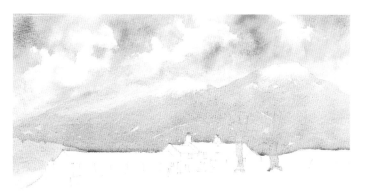

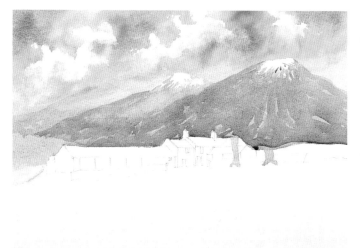

◀ Stage 2

Add some more colour to your wash, then carefully paint in the two nearest mountains, making your brushwork 'go with the flow' of the landscape. Imagine that you are skiing down the slopes; paint how you would ski. This always gives landscape form. Leave the snow as white paper. Wipe in another misty layer between these two mountains.

▶ Stage 3

Mix more French Ultramarine into your wash. Now paint the nearest mountain. Paint a little of this also into the foreground to create dark and light bands across it. This method was much used by the early watercolourists who had only a limited palette, but it is still worth doing today.

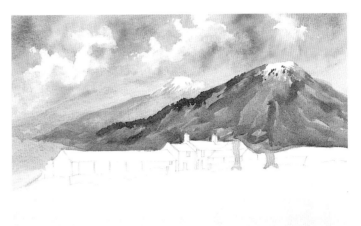

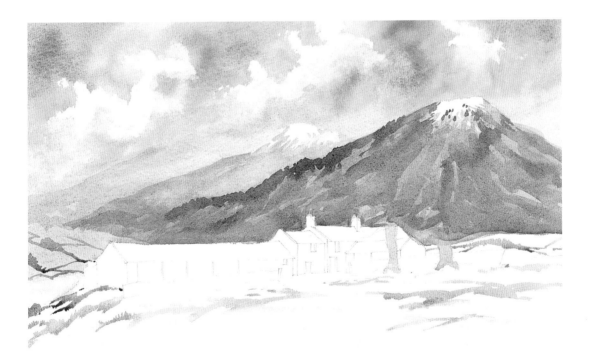

▲ Stage 4

Add more French Ultramarine and some Burnt Umber to the wash and paint in the rocks and gullies on the nearest mountain. Tilt your board upside down and let the paint run up against the sky to create some brilliant rock effects. This colour can also be used to begin to paint the hedges and walls in the middle distance to the left and right behind the farm. Do this very simply. You will not see any birds in the trees at that distance so don't be tempted to put some in – some blobs of colour will suffice.

Stage 3: The foreground

The techniques used in the foreground of a painting, when perfected, will allow you to create many different but lively effects. However, to be effective, you need to practise them so before painting the foreground try them out on the back of an old painting. Watercolour paper is always double sided so you can do this anytime.

▶ **Stage 1**
Wash the entire middle distance with some Raw Sienna, behind and in front of the farm buildings, leaving the path white.

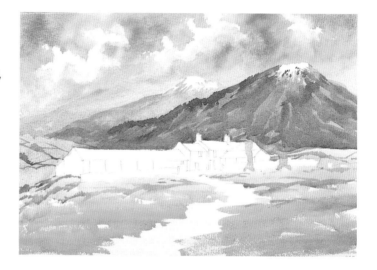

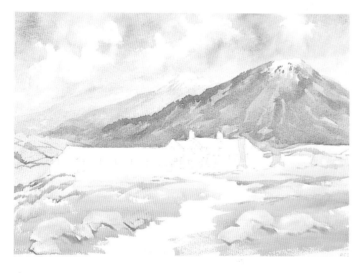

◀ **Stage 2**
Mix a wash of Yellow Ochre, then a strong wash of Burnt Sienna with Prussian Blue – this will make a deep green to use as wet in wet for the foreground. Mix it before you start painting; otherwise it will be too dry for the second wash to work. Have your credit card ready. Paint the foreground with the Yellow Ochre and then create the boulders using your card.

▶ **Stage 3**
Wash in the dark green (Burnt Sienna and Prussian Blue), using a large brush. Tilt your board to help this run down into the painting.

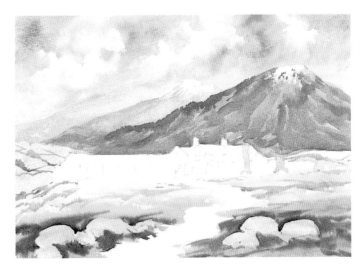

▼ **Stage 4**
Before Stage 3 dries, etch in the grasses and pebbles with your brush handle. The paint needs to be wet. If it doesn't work, it will be because it has dried.

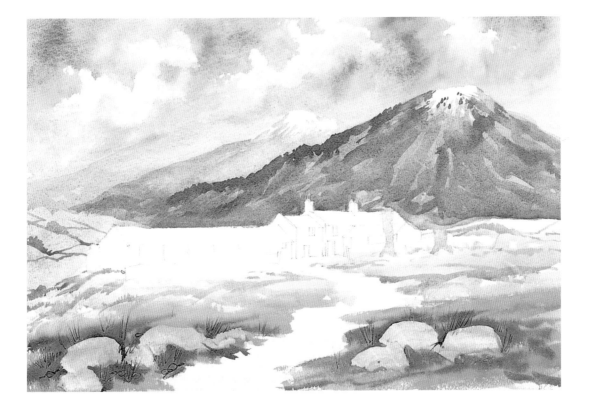

Stage 4: The main subject

Although, at first glance, the architecture appears quite detailed, look again and you will see that actually it is painted very simply. The illusion of detail is one of the best tricks to learn in watercolour. Nothing looks worse than an over-painted subject.

▶ **Stage 1**

Buildings often look as if they are floating about and not part of the painting. To ground them, just paint a dirty wash along the base of the walls, having washed the walls first in clean water. Mix the green from the foreground with Burnt Umber to create the right colour. Add to the base of the walls. It will begin to creep up into the wet area so tilt your board upright to stop if flowing too far.

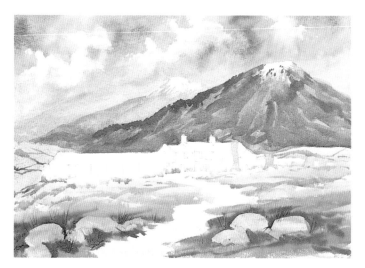

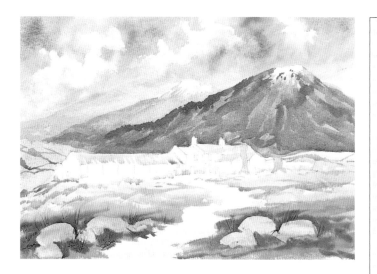

▲ **Stage 2**

Paint in the green lichen on the roofs using Raw Sienna and Cobalt Blue. Paint with the lines flowing down the roofs following the slope of the tiles. Leave some odd bits of white.

Top tip

Creating a 'pig mincer' – an anonymous, nondescript arrangement of dark and light shapes – will add interest to your painting. It will merge into the background and will never be questioned; it just looks like some farm machinery lying around naturally in the landscape.

▶ Stage 3

It is now time to add a few darks but no details. Never be tempted to use black. Instead, mix a wash of Burnt Umber and French Ultramarine. Use this to paint the walls, holding the brush sideways to get a broken wash effect. Paint the darks in the doors, windows and inside the open barn. Leave the latter abstract. The whites left will become what I call the 'pig mincer', i.e. it doesn't look specific, just some machinery.

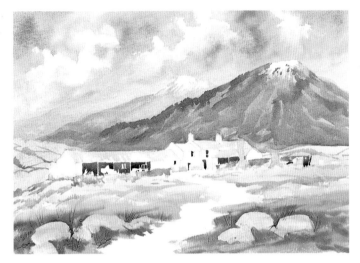

▼ Stage 4

The roof slates can now be painted over the lichen. Do this with pale Cobalt Blue. Be sure the brush strokes come down with the angle of the roofs. You can now see the effect of the whites that you left – great for a roof, aren't they?

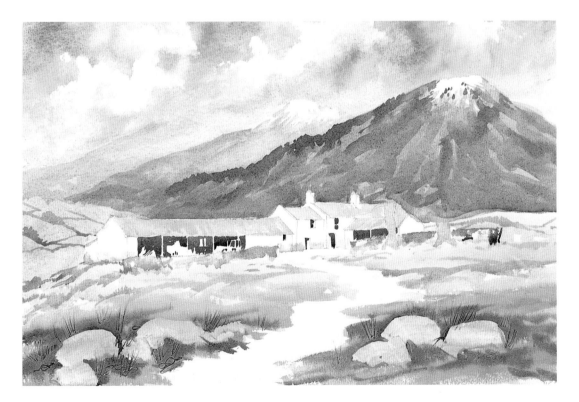

Stage 5: The trees

Most paintings can be dramatically improved by the careful placing of trees. You don't have to put them in where they really are – you have artistic licence. Put them where they will do some work or leave them out totally. Remember the JCB!

▶ **Stage 1**

Brush in the distant trees at the foot of the mountains very simply with a wash of Raw Sienna, Burnt Umber and French Ultramarine. However, don't paint them too dark. They break up the distance and create extra depth in your painting.

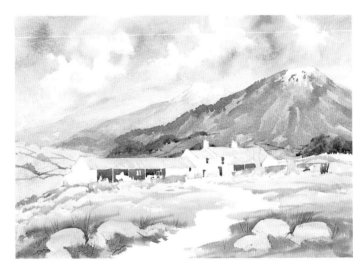

▶ **Stage 2**

The distant conifers are a classic example of trees that work. They weren't in the real landscape but they separate the background from the middle ground. With a wash of Burnt Umber and Prussian Blue, paint a spiky top and ragged bottom which will eventually look like rocks. Fill in the middle area. Dry, then paint on more spikes and a few areas of extra darks, keeping them fairly simple.

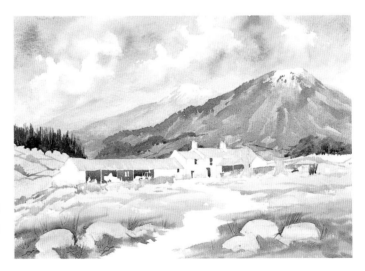

▶ Stage 3

The tall elm trees by the farm are painted with a mix of Burnt Umber and Prussian Blue. Draw a pencil edge for your winter trees. When the painting is dry, it will erase completely. Paint in the main trunks and branches, leaving the bases spiky to look like grass growing up in front.

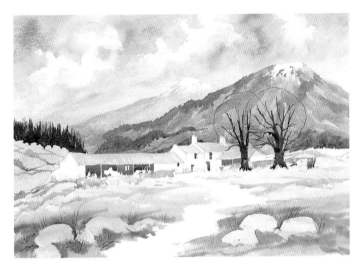

▼ Stage 4

Paint the branches and twigs with the same colour as in Stage 3 but thinned with a little water. Use a rigger for this (see page 83). Left-handed people may find it easier if they turn the painting upside down. Try to keep the lines quite thin – this takes a bit of practice!

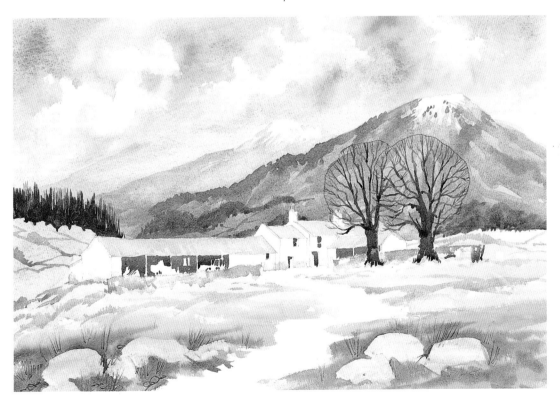

Stage 6: The details

Many paintings are ruined by the fact that there is too much detail. Remember that you get the maximum effect with the minimum effort so resist the temptation to put everything in when you are painting the details. Often, creating the impression of something is more effective than showing it as it really is.

▶ Stage 1

Paint some ivy on the large trees. If any part of the tree looks wrong, then remedy the situation by covering it in ivy. Mix Burnt Umber with a touch of Prussian Blue for this. Use a No. 4 brush and paint the ivy with small, stabbing actions. Before it dries, push your brush handle into it to create the light growth lines.

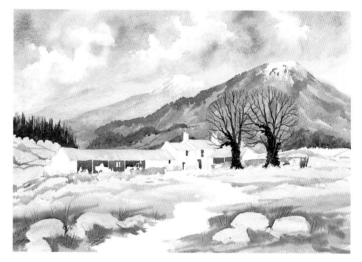

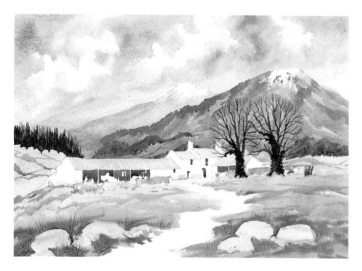

◀ Stage 2

Wash the grass across the foreground of the painting, taking care to leave the path white. Use a thin wash of Cadmium Yellow and Cobalt Blue for this.

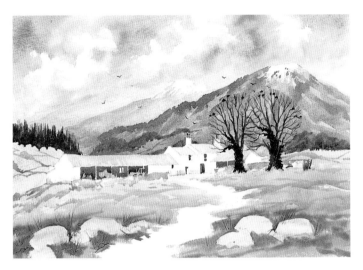

◄ Stage 3

Now it's time to add the details to the main subject, the farmhouse. Add the chimney pots with Yellow Ochre and a bit of dark for the soot. Use colours off your palette and avoid using new colours at this stage. Paint the door and pig mincer with Burnt Sienna. Use Burnt Umber with French Ultramarine for the rooks' nests and birds. Use a pale wash of this for the larger trees, keeping inside the pencil lines.

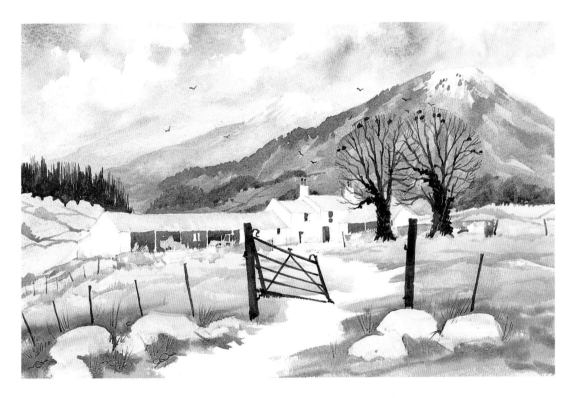

▲ Stage 4

Paint the posts and the gate with a mix of Burnt Umber and French Ultramarine. Always open a gate to lead the viewer in to the painting. If it's left closed, it will stop the eye going in. If you can't paint a gate at an angle, leave it out. For the same reason, avoid putting wire on fences. Make the gate tall enough so that it breaks through the farm. A view of looking through the gate to the farm beyond creates distance in your painting. Now add one or two paler and thinner posts in the distance.

Stage 7: The shadows

This stage of any painting is where the magic occurs. Your subject will suddenly appear three-dimensional and sunlit. Study the painting carefully before adding the shadows. If you go back to your original drawing and shade this in pencil before you paint, you'll know which direction the light is coming from and where the shadows need to be.

▶ **Stage 1**

Gradually add some French Ultramarine to plenty of Burnt Sienna until you get a grey. Test the colour on a scrap of paper. Let it dry, then hold it against your painting. If it's too dark, add more water to tone it down. Using a No. 6 brush with a good point, shade the rocks in front of the pine trees and the shadows of the farm on the ground. Then shade the farm buildings.

▶ **Stage 2**

When Stage 1 is dry, use the same wash to shade the shadows from the trees which fall across the ground and up over the roofs of the farm buildings. Add the shadows on the stone walls.

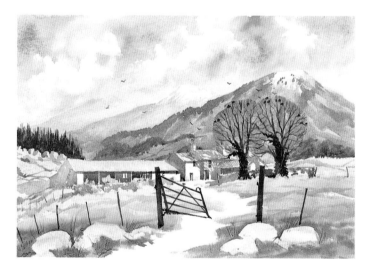

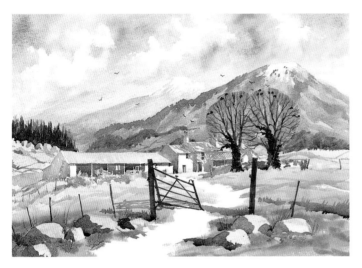

◄ Stage 3
Stir the wash again and then use to shade the shadows of the posts and gate. Add the shadows under the boulders and on the ground below them. Leave it all to dry thoroughly before moving on to the last stage and adding the finishing touches.

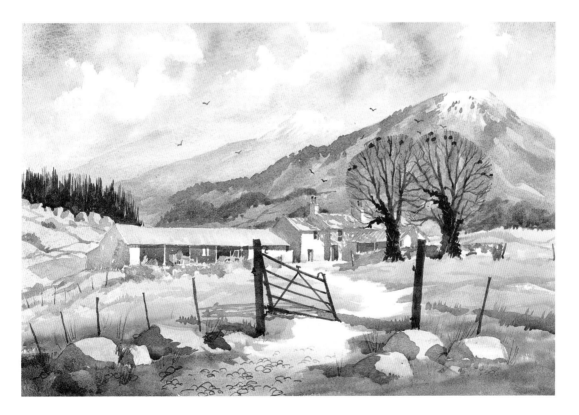

▲ Stage 4
Mix all the colours left on your palette, adding a touch more French Ultramarine. This is what I call my Art Room Sink Wash. Wash the foreground with water, then add the wash across the front of the painting. Etch more pebbles across the path with a brush handle, then tilt the painting upright so the wash settles at the base. Leave it like this until dry. This simple finish leads you over the cool foreground to the warmth behind!

Painting Skies

Virtually every watercolour landscape you paint will have a sky. However, because skies are constantly changing, no sky will ever look the same as another. So many factors can affect it – the season, the weather conditions, the time of day. The painter's biggest problem is trying not to make it photographic; leave that for cameras and filters.

Painting simple skies

You can use some very simple techniques to create great skies which will complement most subjects. Although skies can appear complicated at first to the beginner, they are relatively easy to paint. Start off by following the step-by-step process illustrated opposite. Once you have mastered the basic technique of using a graduated wash, you can then progress to creating various types of cloud formations and experimenting with different types of skies and weather conditions.

▼ **Simon's Seat, Wharfedale, Yorkshire**
27 x 46 cm (10 x 18 in)
In this sky, there are three blues: Coeruleum for the initial wash; Cobalt Blue and French Ultramarine for the stronger wash. Burnt Umber was added to create the thundery tops to the clouds, and Raw Sienna finally for warmth.

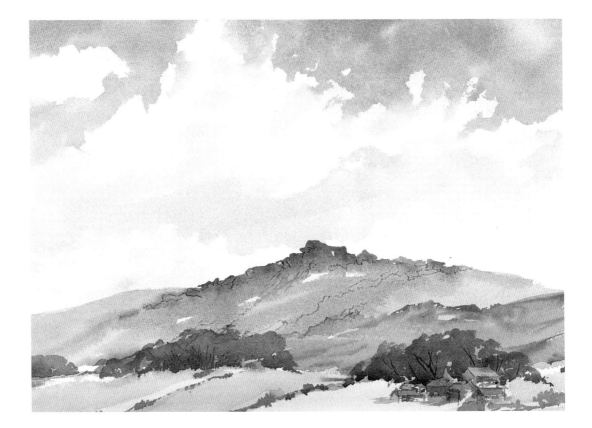

Graduated wash

This is as simple as a sky gets. All you need is a graduated wash progressing from deep blue at the top to a pale blue at the horizon.

▲ *Wet the whole area, then add a strong wash of French Ultramarine across the top with your mop and keep on brushing with horizontal strokes until you reach the bottom. Never go back! This needs practice and the technique will not work on anything other than watercolour paper.*

Wispy clouds

Are there any simple shapes you can see that will give you a lead as to how much white there is in a sky? Check this and then create some wispy clouds.

▲ *To create wispy clouds, such as cirrus formations, fold some tissue to form a thin pad and then swipe it across your wet sky at a slight angle.*

Lifting out

Having mastered the graduated wash, the next step is to try lifting out lights for the clouds. For this, you will need some tissue.

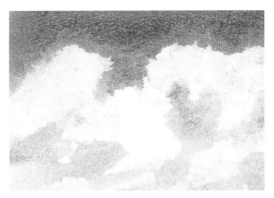

▲ *Wet the entire sky area to release the gelatine; otherwise the colour will be absorbed straight into the paper and will not lift off effectively. Now crumple up some tissue and roll it across the freshly painted sky to create the cloud shapes.*

Darker areas

To create darker areas, mix your blues together. Have plenty ready or you may get watermarks where the wet paint meets the drying paint.

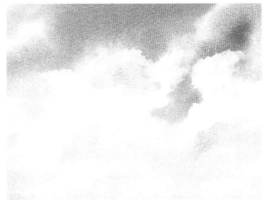

▲ *Paint the sky, lifting out the clouds, and, with a No. 4 brush, push darker paint into the wet areas, scrubbing it in to make it stay where you place it.*

Shadows in clouds

To help define the clouds in some skies, you will have to shade them in the same way as the subject on the ground. To add shadows to clouds, you can add some neutral tint to the sky blues to create a grey shadow tone, or you can mix the blues with some Payne's Grey.

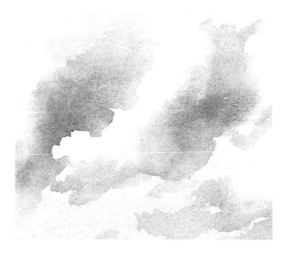

▲ *Here, the sun was coming from the left so the shadows go along the base, up the right-hand sides of the clouds and are softened in the middle. The shadow tone is Light Red and French Ultramarine.*

▼ Peter Scott's Lighthouse, Lincolnshire

38 x 56 cm (15 x 22 in)

This was painted quickly for one of my television programmes. It was a hot, sunny afternoon and the clouds were beginning to bubble up. The paint was drying so quickly that I barely had time to soften the shadow edges. I washed a little of the shadow tone over the horizon to make it seem miles away.

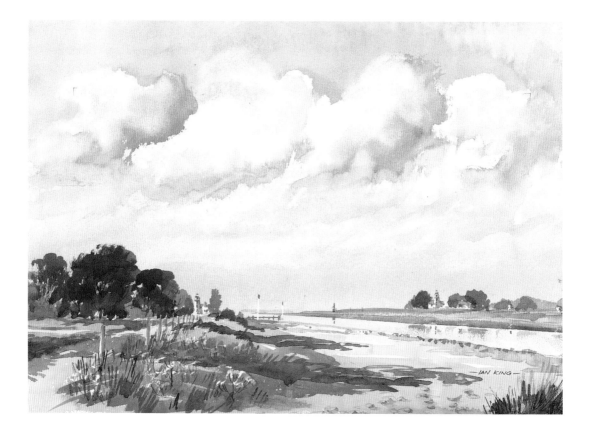

Creating mood

The skies so far have all been tackled in one go. However, more atmospheric effects can be created when a sky is partially painted and then left to dry before further layers of colour are added later. To create subtle mood in your watercolour paintings, the sky will usually need only a pale wash, often with a base wash of Raw Sienna to add a sense of warmth and depth; the subtlety is added to this afterwards as shown in the examples below.

▲ *In this example, the sky was painted as a simple cirrus sky. When the blues had dried completely, I washed the sky over with some Raw Sienna to create a hazy early morning sky.*

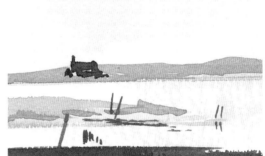

▲ *The working study above is relatively small but it does show how a simple subject can be changed by varying the sky and the depth of colour in the background and foreground.*

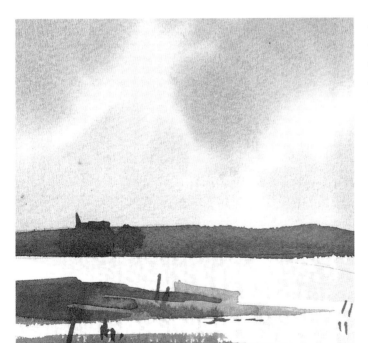

◄ *I have added Raw Sienna to the same subject. See how this creates a totally different, warming effect. It's a good exercise to practise this with different subjects, adding a variety of skies.*

Morning and evening skies

As we have already seen, a situation that reflects a particular weather pattern can dramatically affect how you paint the sky. Adding a wash of Raw Sienna to a sky can create a warming effect and this is especially useful when you are painting early morning or evening skies. After the initial wash of Raw Sienna, try adding a blue wash and graduate it down thinly.

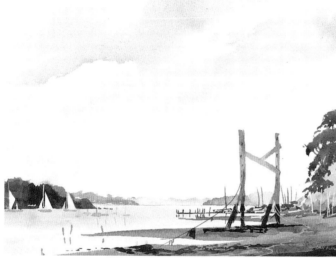

◄ Early Morning on the Orwell, Suffolk

29 x 41 cm (11 x 16 in)

The light here was coming from behind. The whole painting was washed with warming Raw Sienna as practised by Turner in his sketchbook journals. To create a morning sky, the Cobalt Blue was washed in so thinly that it dried to nothing at the horizon. I painted the rest of the sky with bands of stronger Cobalt Blue and lifted out the light gaps. Distance was created with transparent washes in the distance and opaque washes in the foreground.

► Evening Sky at Bamburgh Castle, Northumberland

22 x 32 cm (9 x 12 in)

Raw Sienna is the base, even under the sea wash. The pale sky blue wash was added to the Sienna when dry and this was strengthened for the sea. The remaining washes were made from Light Red and a touch of Burnt Umber with French Ultramarine. The sky was re-wetted and the first clouds dropped in and left to spread wet in wet. The second layer was thinned with water and then brushed on dry to create the broken edges of the evening clouds.

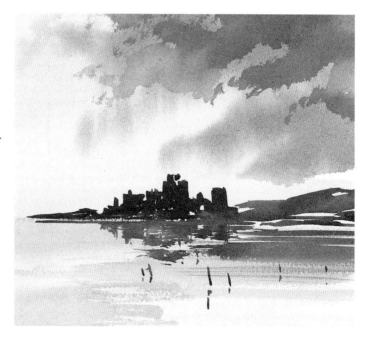

Dramatic light

Light effects in paintings will usually be most effective when the light appears to come from the back of a painting. This automatically means that the subject will be painted as a silhouette, with the facing side in shade. These kinds of study can be quite difficult when you have to assess the strength of the foreground. Below I show two distinct types: one with a very pale foreground and the other very dark. They both work effectively but notice that where the sky is pale the foreground is pale, and where the sky is strongly painted the foreground is dark.

◄ **Morning Tide at Old Felixstowe, Suffolk**

32 x 44 cm (12 x 17 in)

The paper was wetted and a wash of Raw Sienna added. I removed the watery autumn sun with a tissue to create a circle of light, then swiped the tissue down into the Sienna below to create the light in the sea. Very pale washes were then added with the solid objects painted in mixed greys.

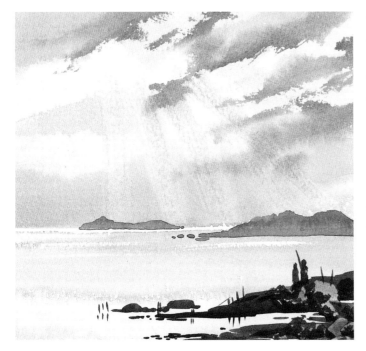

◄ **Scottish Islands**

20 x 25 cm (8 x 10 in)

The contrasts between light and dark make this study work, but you must judge the right moment to swipe the light areas out of the sky. Lift them out too soon and they will flow back into the damp area; leave it too late and they won't come out. The sky was wetted and Cobalt Blue added. Some light areas were lifted out. The sunbursts were lifted out from the light patch at the top down to the sea. They are never parallel and always fan out. By adding the islands in opaque colour they appear to be shaded so the light falls between them.

Painting different skies

The sky above us is constantly changing as clouds form, storms brew up, and the season or time of day changes. The examples here will help you to look at different seasonal and weather effects and create a shorthand method for painting them.

There is no such thing as a specific 'type of sky' as it changes throughout the day. The light will alter as you turn to face in a new direction, so the variables are endless. As you become more skilled as a painter, you will find that your powers of observation are more acute and the better your visual understanding will become.

You need to be able to paint not only clear summer skies but also rain clouds, stormy skies and leaden winter skies above a snow scene.

Winter skies

In winter, when there is snow on the ground, you always need a Raw Sienna base to the sky. Snow reflects a lot of light back up into the sky and shadows will be more blue or mauve.

▶ Winter Snow Scene

28 x 38 cm (11 x 15 in)
This late afternoon sky in the dales in winter was created by wetting the entire sky area with some water before adding a wash of Raw Sienna. When dry, the sky was rewetted and a wash of Raw Sienna and Alizarin Crimson was streaked across it and then allowed to spread in order to create the soft effect that you can see here.

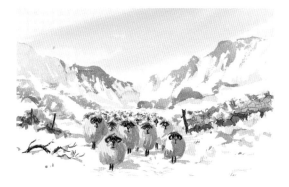

Stormy skies

For these skies, you will need to use vigorous brush strokes and stronger colours. Be prepared to work fast and decide from which direction the light is coming and also how the shadows on the ground will change before you start painting with a pale Raw Sienna wash.

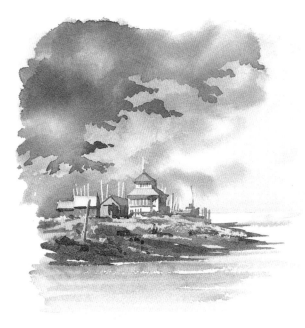

◀ Storm over Felixstowe Ferry

The clouds were painted on to Cobalt Blue whilst still wet with a strong mix of neutral tint and French Ultramarine to give them a soft-edged rainy look. When dry, the same wash was brushed on again. It dried with strong edges and looks menacing. A Raw Sienna wash was added to this.

Rainy skies

These are usually painted wet in wet, adding greys and pale browns to the clouds over the blues towards the horizon to create the impression of falling rain.

Summer skies with clouds

Towards mid afternoon on a hot and very still summer's day, clouds often begin to form as the moisture rises. These skies are basically pale and warm and to paint them you will need some Coeruleum or Manganese, washed on very thinly.

The clouds can then be lifted out, getting progressively smaller as they recede. Shadows will be there but these will be very pale and can be made with a touch of Burnt Umber mixed with your sky colour. Test the colour first on a scrap of paper and let it dry so that you know how dark it will look in your painting. When dry, a wash of Raw Sienna will complete the feeling of warm humidity.

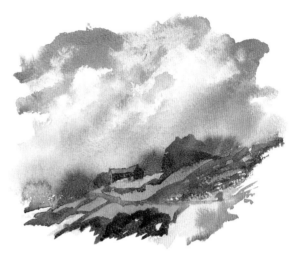

▲ Ramsbottom Rain

The sky was painted strongly with French Ultramarine, then blotted to create the light areas. Payne's Grey was added and the background washed into it wet in wet. The details of barn walls and trees were added later.

▼ Oby, Norfolk

21 x 41 cm (8 x 16 in)

For summer skies, make everything in the distance look really pale. Imagine you are looking at this through a hazy fog and dull it accordingly.

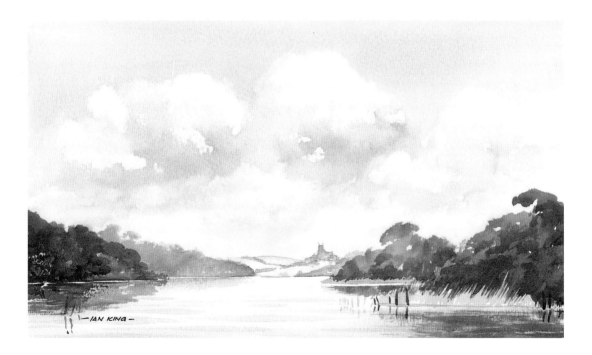

Painting Backgrounds

Success in any painting depends on how you treat the background. It should always be painted transparently, often with washes created from Raw or Burnt Sienna applied on top of a sky wash. A background added with an opaque wash will always leap out at you visually, thereby ruining any sense of distance or recession.

Creating transparency

Think of your painting like a stage set in which the background is the backdrop right at the rear. It won't have much detail and it will usually be quite pale. The brighter, stronger colours and the details will be saved for the parts of the painting that are nearer to us. To ensure the transparency works, check a colour chart – these are available from every art shop. Colours marked with a 'T' are transparent and fine for you to use; those marked with an 'O' are opaque and aren't suitable for backgrounds. More recently, some manufacturers have started to indicate this on the tubes of paint.

The simplest way to create distance in your paintings is often a treeline, usually painted without trunks or any real definition. It is also transparent and is painted over the sky wash. Trees in the distance will never appear as dark as trees in the middle distance or foreground of your paintings. Even though they may look as dark in real life, they have to be painted paler.

▼ Storm Over the Ruins
22 x 37 cm (8 x 14 in)
Simple undulating tree lines show background hills perfectly. They are painted over the sky transparently and the gaps of sky add depth without detail.

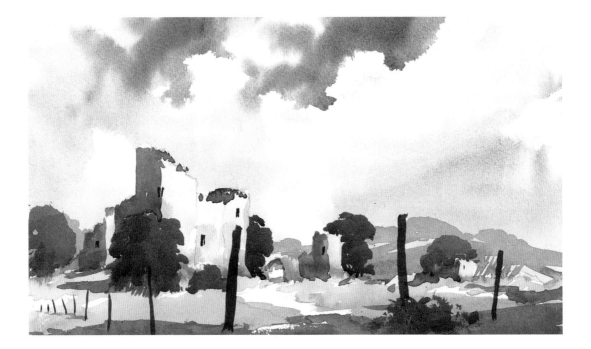

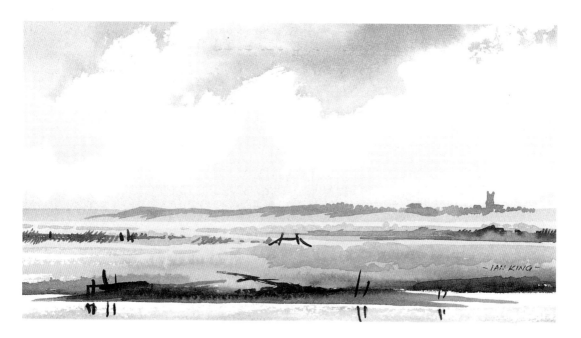

Flat and hilly landscapes

When you paint a flat landscape, normally there will be more layers of colour, which may be very subtle. Alternatively, some areas may be left unpainted. It will usually be one-third land and two-thirds sky whereas a hilly landscape will usually be two-thirds land and one-third sky.

▲ **Looking Towards Winterton, Norfolk**
16 x 33 cm (6 x 13 in)
In this study of a church tower seen across the marshes, each layer of colour helps create the feeling of depth. The band of Raw Sienna across the centre and the green bank behind are painted in the same wash. The use of slightly darker opaque washes as a contrast in the foreground gives it wonderful depth.

▶ **Farm at East Bergholt, Suffolk**

15 x 20 cm (6 x 8 in)
The same technique of using Raw Sienna washes over the sky wash can be seen in this example of rolling farmland. The background is simple, understated, and pale. The tree lines are simply added in pale French Ultramarine, the farm in very thin Burnt Sienna and the roofs in more French Ultramarine. If doors, windows, cows and tractors had been added, the study would have been ruined with detail.

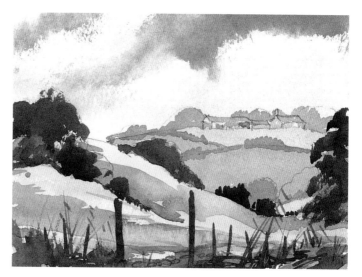

Distant buildings

When there is a village in the distance, you may be tempted to overpaint it. Bear in mind that the less you put into your painting, the better it will look. Less is more and you will get the maximum impact with minimal detail in many paintings.

You may feel overwhelmed by a subject because a town or a great urban sprawl is in the background. However, all you need do is take a long hard look and analyse the main shapes of colour in the architecture. Forget that it's a town; it's going to be simply a collection of coloured shapes in your painting. Shadows

▲ *This shows how you can paint great architecture with a touch of Burnt Sienna and some grey mixed with Burnt Umber and Cobalt Blue. When it's dry, add the shadows in a slightly stronger grey.*

and trees will add the finishing touches and create the illusion of a town. My watercolour of Rye (below) demonstrates what you can achieve by keeping your painting simple and transparent. Look at the architecture; most of it was painted in simple shapes in earth colours, with the random shapes left as white paper. It looks quite solid although it is basically an abstract collection of colours.

▼ View Over the Marshes

36 x 56 cm (15 x 22 in)
Buildings viewed across water are painted with pale and transparent colours. Add the reflections with the same washes and avoid painting exact mirror images.

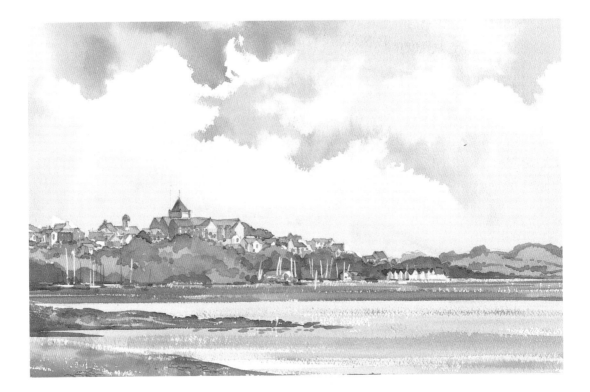

Woodland backgrounds

Trees and woodland work very effectively as backdrops to subjects with architecture, or simply to show distance and scale in open landscapes. Where the trees are close behind buildings you can afford to make them stronger than those painted in the distance. They can also have more definition even if they are painted loosely. In subjects where there are distant mountains, a solid treeline will work wonders for adding recession to a painting.

Top tip

Even in flatter landscapes, trees can be used to create the entire background. When you are painting pine trees, adding a wide range of transparent and opaque greens around any buildings will help to create a feeling of distance and recession in your painting.

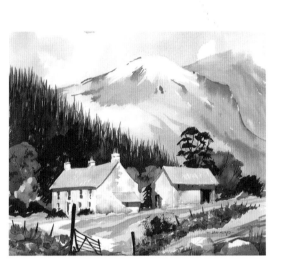

◀ **West Head Farm, Cumbria**
33 x 33 cm (13 x 13 in)
Pine trees coming down a slope in the middle distance add depth. A few solid deciduous trees around the buildings separate the subject from the background.

▼ **Summerhill Farm, Norfolk**
18 x 38 cm (7 x 15 in)
A line of transparent trees was painted behind the farm, then more opaque trees were added with the four strongly coloured trees around the farm.

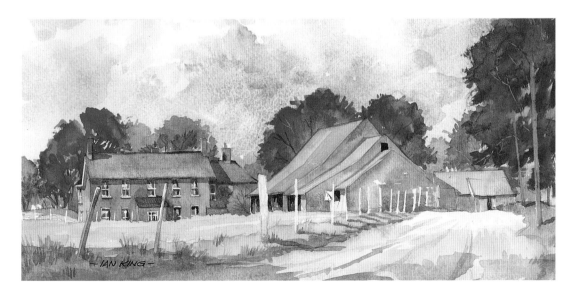

Mountains and hills

Hills and mountains are ideal for showing weather conditions and also the height of the viewer in a subject. A simple range of mountains in the background to a painting can be blotted out to show mist, boats and even a lighthouse, and this is always better done on a wood-based paper. A high foreground with hills behind creates the impression of looking up at the subject, whereas hills that are low in the background give the feel of looking down at it. Both are achieved through changing the eye level by moving the finished height of the background.

▶ **Moorland Farm**
22 x 35 cm (8 x 14 in)
This uses the seven stages but moves the subject to the top third of the painting for a more dramatic study.

▼ **Lulworth, Dorset**
32 x 48 cm (12 x 19 in)
This landscape is viewed from a high vantage point. The background hills are kept low and the sky brought down behind them. The layers of trees get progressively smaller.

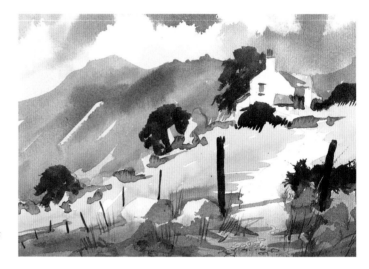

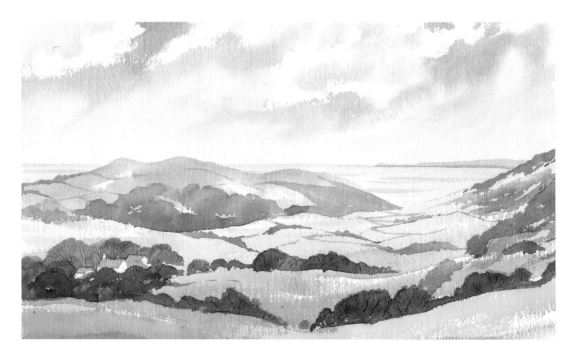

Background weather

The prevailing weather conditions will influence the way in which you paint the background. For instance, a soft mist can be created simply by wiping off a layer of paint. An equally effective method is to paint the background over a wet sky.

To paint snow on mountain tops, you can either blot out the white areas or leave them unpainted with the white paper showing through. If you wish to show more detail, the mountains will need to be more dominant. They can still be a feature of the background but they will appear much closer.

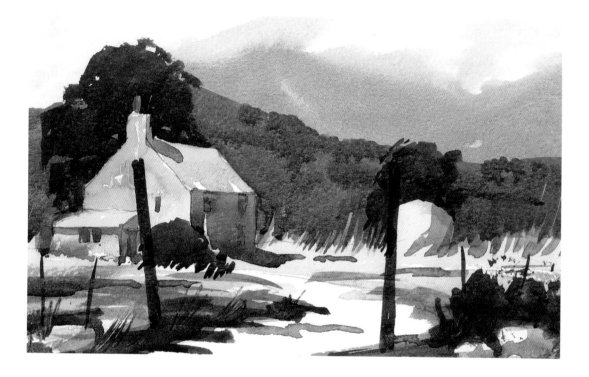

▲ Rain Approaching
17 x 23 cm (7 x 9 in)
This shows how to create a misty effect by laying the background on a wet sky and tilting the board until dry.

◄ Early Snow in Perthshire
15 x 23 cm (6 x 9 in)
By drawing the mountain outline lightly in pencil you can paint the sky very wet. Leave the snow peak as dry paper before adding colours to the sky.

Painting Foregrounds

The foreground is a very important part of any painting – get it right and the painting will virtually look after itself. An effective foreground will lead the eye in and create interest. It does not have to be very detailed but, more importantly, it marks the change from transparent background washes to the use of opaque foreground colours.

Two approaches

In some paintings, a foreground will work simply because of its opaque treatment whereas in others its success is due to the etching and embellishment of the opaque colours. These are two very different approaches but they are both equally effective when used in context.

▼ Dales Landscape

17 x 39 cm (7 x 15 in)

The foreground was created by using opaque Yellow Ochre on top of transparent Raw Sienna. This gives the landscape depth and distance. It has been enhanced by lifting out a few boulders with a credit card and adding some opaque greens and the posts.

▲ Norfolk Coastline

15 x 23 cm (6 x 9 in)

A simpler example of opacity and transparency would be hard to find. Whereas the background was painted onto the sky in a transparent wash, the foreground was added simply with opaque washes.

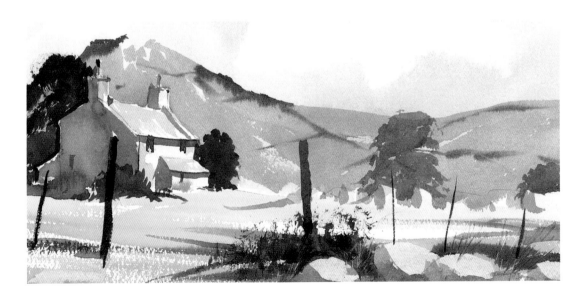

Using the middle distance

As the foreground will usually start at the focal plane (see page 34) and finish at the front of your painting, it will usually include all of the middle distance. The content of the middle distance will vary with the type of subject. In some cases it will be built up with light and dark bands; in others it will only need simple washes as the background will be more obvious.

▼ **Burnham Marshes, Norfolk**

16 x 35 cm (6 x 14 in)

The use of light and dark bands can be seen here. With a flat landscape, it is the only technique that works. Some of the dark areas are painted as grasses and reeds or simple shrubs and bushes, and the subject can be painted in the same brushwork. This will make your painting look cleaner. In some subjects the same effect can be achieved simply by painting layers of trees.

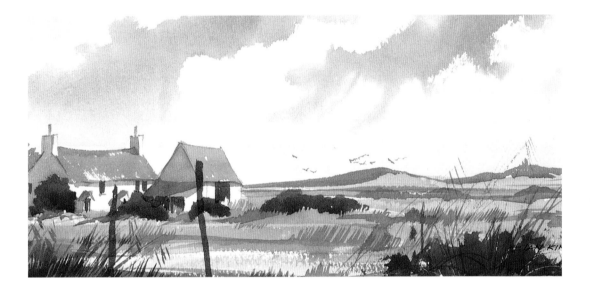

◀ **Seven Sisters, Sussex**

38 x 56 cm (15 x 22 in)

Where the background is obvious, the foreground can be painted in a couple of simple washes. The background was painted using transparent washes and the foreground with opaque colour. A couple of simple areas of shrubs and a path to lead the eye into the subject completed the foreground.

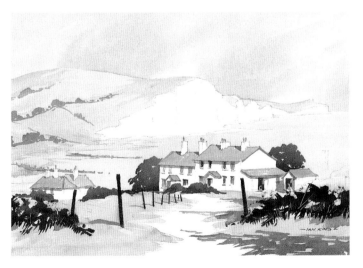

Embellishing foregrounds

Adding some extra touches to a foreground will make it more individual. For example, it may be your style to always add some posts or a detail such as an old plough. Alternatively, you may simply get your inspiration from seeing the subject as presented to you and want to replicate it, detail for detail. Whichever way you like to paint, the foreground should never look overworked – the simpler the better. In fact, the most effective foregrounds feature only the minimum of embellishments.

▼ Cromer Pier, Norfolk
28 x 42 cm (11 x 17 in)
After the ebbing tide, there were wonderful reflections of the pier stantions in the wet sand. This painting shows the opportunities that a foreground can provide for painting creatively.

▶ Boats at West Runton, Norfolk
28 x 48 cm (11 x 19 in)
I painted the boats, beach and cliff in loose washes and used ink to redefine the main subject. A few pebbles were added to the beach and picked out when adding the shadows. This simple approach makes the foreground work well and is worth trying when the subject is almost a foreground.

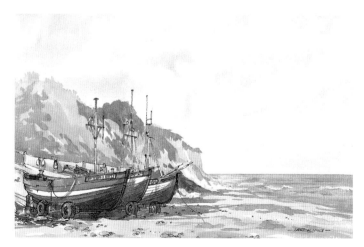

Pebbles

The simpler and bolder your treatment of a foreground, the better it will work. However, the problem is often how best to add some objects or details that are not there in reality. There are some subjects where a simple, unembellished approach will create a better foreground, but there are others in which just a simple wash or two will not be enough. It is in these situations that I often resort to adding pebbled paths or grasses and reeds to make the foreground work. They may look difficult to paint but are actually very easy if you use an etching, masking or opaque colour technique.

Here are some step-by-step examples to show you how to create the little additions that will do so much for your foregrounds.

1 *For light pebbles on a dark path, mask their shapes with some masking fluid first. When dry, add some dark colour over the path.*

2 *You can make pebbles look wet simply by painting a pale wash of Cobalt Blue over the path after you have removed the masking fluid.*

1 *A wash of Raw Sienna will mark the path shape. Use horizontal, not vertical, brush strokes across the foreground.*

2 *Add some Yellow Ochre and Burnt Sienna to the area that is nearest to you; this will create your opacity.*

3 *Whilst wet, etch the pebbles with a brush handle, making the marks progressively smaller as they recede into the distance.*

4 *Finally, add a wash of darker colour over the immediate foreground to make the pebbles appear even stronger.*

Reeds and grasses

There are three basic methods of painting grasses and reeds in the foreground of a picture as demonstrated here. Deciding which method you are going to use will depend on the type of subject you are painting.

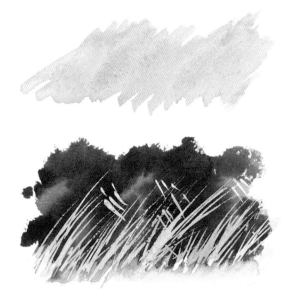

▶ *Light reeds against a dark middle ground can be very dramatic. Wash in the greens for the reeds first, then let this dry well and paint the reeds with masking fluid. This enables you to keep the light grasses. When the darker middle distance greens are added, the reeds will appear as if by magic when the masking is removed.*

◀ *In light areas, such as cornfields, add a few simple washes in horizontal bands, the colour changing only very slightly between them. They can be etched with a brush handle to give the effect of larger expanses of grasses.*

▶ *By mixing a little opaque white with Yellow Ochre, reeds can be added to the immediate foreground with a rigger. Practise this before you attempt it in a finished painting. You will not be able to remove the reeds if they go wrong!*

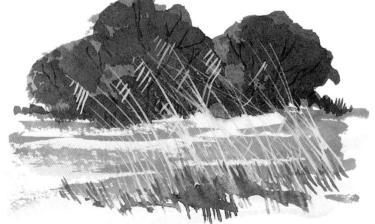

Other foreground features

Obviously, we cannot cover every type of foreground you may need, but here are some more examples to help you interpret what you see. Whatever you try to include, remember that simplifying a foreground and making it bold is always the best approach. Fussy, overworked foreground details can spoil any painting. If the foreground in front of you is very busy, consider how you can make it simpler and which items you need to include – three posts will often look far better than ten. Alternatively, if there is nothing obvious in the foreground, can you borrow something from elsewhere to make it more interesting?

The most difficult of foregrounds are those where you need to show perspective; this is often in open farmland subjects. Whatever the ruts or crops are actually doing, you may need to change their direction so that they lead the viewer's eye into the painting. Ruts or crops crossing a foreground will ruin the sense of distance that you are trying to create.

▶ *A beach can be enhanced by the addition of an old fish box and a tractor track. Etch in a few pebbles and the effect is brilliant. It can also be used to lead the eye into the painting.*

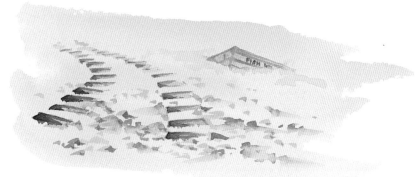

◀ *Snow covers most features in a landscape, but an old tree trunk lying on the ground will still be seen even if it is partly covered in snow. These are the details to look for.*

▶ *I often use an old gate in my paintings but remember to open it or it will stop the eye entering the painting. It looks timeless if it hangs off its hinges.*

Identifying the Main Subject

There is a subject everywhere so why is it so difficult to identify what we want to paint? Painters are natural observers, and the more we paint, the more we see. Training ourselves to look helps us to find a subject or, as my father put it, 'Learn to look and the subjects will look after themselves'.

Landscapes

All landscapes vary enormously in their style and content – for example, they may be flat, hilly, mountainous or even a seascape. When looking at a potential landscape as a subject for your painting, the best advice I can give you is to look at the subject, think about it and then plan your picture carefully. A good way to do this is by sketching it first. Only then will you fully understand your subject.

When you are planning a landscape, always remember the rule of thirds (see page 32) and never place the subject right in the centre of your painting. Decide whether it looks best a third of the way up or down, or a third of the way in from the left or right. Where you position the subject will dramatically affect the impact and mood of the finished painting.

▼ Broadland Pumpmill

15 x 20 cm (6 x 8 in)

With the mill dominating this painting, a simple sky and background were washed in first transparently. The mill and reeds were painted in opaque colours afterwards when the background was dry.

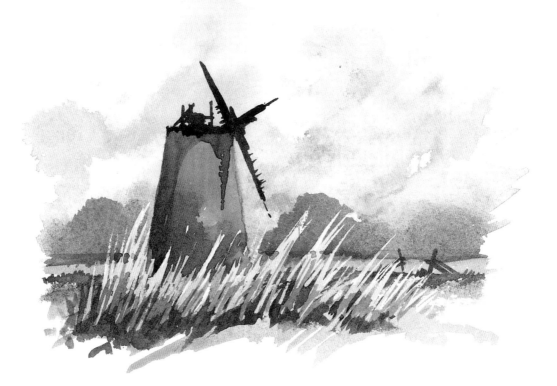

▶ Orwell Estuary

16 x 29 cm (6 x 11 in)

Early morning light, a few distant trees and the view across the estuary. A more simple subject would be hard to find, but it still needs planning. Where will the horizon be? Where will the change from transparent to opaque colour take place? How will I show the mud in the river? You need to ask yourself all these questions before you start painting. Do I look straight across the estuary or look down into it? What will create the best sense of distance?

A more simple subject than this picture of an estuary in the early morning light (right) would be harder to find but it still needs planning. For instance, where will the horizon be? Where will the change from transparent to opaque colour take place? What's the best way to show the mud in the river? Should you look straight across the estuary or down into it? What will create the best sense of distance? You need to ask yourself these questions before you paint.

The painting of St Bennet's Abbey (below) has an obvious subject. The background and foreground are easy to see and plan and are defined by the sky, which is painted down behind the abbey.

▶ St Bennet's Abbey, Norfolk

24 x 32 cm (9 x 12 in)

St Bennet's Abbey, Norfolk has an obvious subject, and the background and foreground with it, easy to see and plan. The sky is painted down to behind the abbey, this creates the foreground and background areas perfectly. You can easily see where the sky wash came down to in this study. A great opportunity to add a sky with rain approaching over this Broadland landscape, the sails in the distance were lifted out with a stencil and sponge.

Buildings

Architectural subjects present you as a painter with a number of possibilities. For example, the subject can contain buildings or the architecture can actually be the subject. Normally where you place the building(s) will be the deciding factor. If the subject is positioned quite large in the foreground, you will have the opportunity to add far more detail and to concentrate on the architecture itself. Consequently, there will be less detail in the background.

However, if the building is placed in the background, the way in which you treat it will be far simpler. However, this does not mean that it will be any easier to paint so don't use this as your rationale when making a decision. At the planning stage, ask yourself how you want to paint it and sketch it out both ways if necessary to see which approach looks better.

▶ Welle Manor, Norfolk

38 x 56 cm (15 x 22 in)

Here the architecture itself is the subject. When you paint a building as close as this, you can make full use of your skills at painting details and this can be most rewarding. Keep your background to an absolute minimum with this type of watercolour.

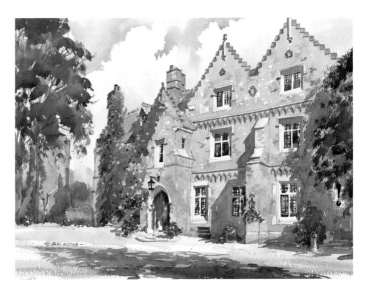

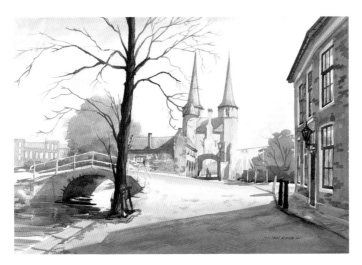

◀ Ouestgate, Delft, Holland

38 x 56 cm (15 x 22 in)

By placing this mediaeval town gate in the middle distance, it draws the viewer's eye past the tree and bridge into the archway itself. A simple suggested background creates depth. By adding some foreground details to the painting, I could include some of the elements that make it look quintessentially Dutch.

Archways

An archway can add interest to your painting and will create a sense of depth. Not only will it lead the viewer's eye into a picture but it will also suggest a world beyond the immediate foreground. It can frame the subject or become the subject of the painting. It is advisable to make a rough sketch first to plan out your painting and get the perspective right.

▼ Castle Acre Gateway, Norfolk

Using an arch to frame the subject can give a study wonderful depth. I painted this in situ with a watersoluble ink pen for the drawing and then washed it out using a No. 8 brush with water. The colour was added from a very limited palette, and what an effect! This style can make architecture real fun to draw and paint.

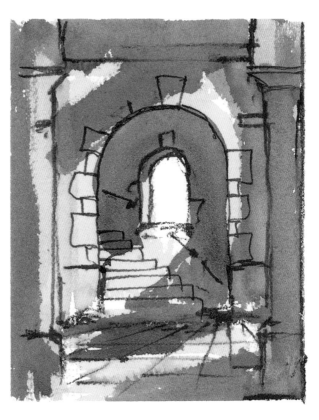

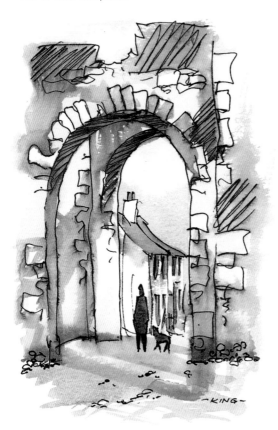

▲ Stairwell, Castle Rising, Norfolk

16 x 12 cm (6 x 5 in)

Often the best way to paint a complex subject like this is to paint in areas of colour and draw into it with a watersoluble pencil. It keeps the subject simple and achievable. If you look at this closely, it is amazing how little drawing was actually required. The major part of the work here was done with the shadows added when it had dried. These postcard-sized studies are useful learning exercises and will help you master your drawing skills.

Painting Trees

Like every watercolour painter I have ever met, I too had a problem with trees when I began painting. Initially I avoided them but eventually I had to paint them and I soon realized that they are not nearly so difficult as they first appear and that there are some very simple techniques to help you.

Placing trees

When you feel confident about painting trees you will have gained a whole new vocabulary to paint with. Trees can make or break a painting but not, as you imagine, because they look awful but more by where you place and how you use them.

The illustrated examples below of a farm with haystacks show you just what trees can do. Try this yourself. Take some traces of the original drawing. Paint a simple sky, add a background and then experiment. Vary the strengths of the greens and the relative sizes of the trees. The effects of depth will vary enormously.

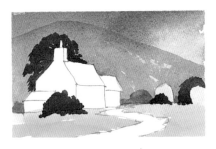

1 *Painting a few simple background trees with Raw Sienna and French Ultramarine helps to separate the middle ground from the background hills.*

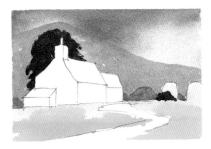

2 *An opaque tree placed behind the farm brings the farm forward, whilst the bush added in front of the haystack seems to send it back. This wash was made by mixing Yellow Ochre and French Ultramarine.*

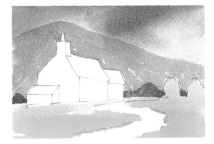

3 *A bush was painted in front of the farm, bringing the foreground forward. Another bush behind the other haystack makes it appear nearer.*

4 *Finally, a couple of gorse brushes in the foreground add interest and bring the foreground well forward.*

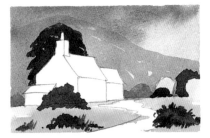

Painting distant trees

Painting background trees is easier if you create a line to sit them on. The colours will be pale and transparent, usually paler than they appear in reality. Trees that are opaque or too dark will jump out at you and not recede effectively. If the background is flat, start with a flat broken line. If it is undulating, the line should follow the landscape. Using the edge of a brush, add the foliage down to the line by simply dragging the brush downwards – use the edge, not the point.

Top tip

When painting trees with foliage your best friend will be that old brush with no tip, the one you were about to throw out!

▲ You can use this same technique to show fields and hedges in the back of a painting. Keep these very simple.

▲ Middle-distance trees are painted using the same method, but the colour can be made more opaque by adding some Yellow Ochre.

▼ If you need a misty effect, such as you would see in winter, simply wet the paper above your line before painting the trees in. Tilt the board upright and you will have a misty outline effect.

Painting woodland trees

Solid forests are a huge challenge and may even be impossible to paint in watercolour so you are better sticking to subjects that have woodland as a backdrop or trees with gaps between them as a foreground. Why is this? The problem we have with watercolour is keeping our light which comes from the white paper. A mass of forest becomes muddy very quickly and loses its light.

You need a variety of greens to paint trees effectively, usually made by mixing earth colours and blues and greens but never with greens straight from the palette. These always look very acidic and are not suitable for deciduous trees. Trees in summer will look better with gaps left in the foliage to look through to the background; trees in winter will invariably be more effective with a foreground and painted wet in wet against a background sky.

Trees in recession

Often you will see a row of trees that are painted dark on light. The dark trees or hedges are painted first, leaving gaps, and when dry the lighter tree colours are painted in between. All this can be overpainted with additional greens later. This technique will give you a good sense of recession.

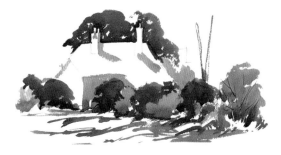

▲ *You can see this technique used in the hedgerow leading the eye into this little watercolour sketch.*

▶ **Winter in Norfolk**
Here the treeline was painted over the wet sky to give a soft edge. The trunks of the trees were etched in with a brush handle.

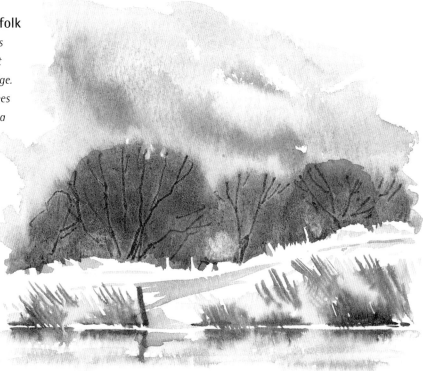

Different types of tree

There are so many species of tree that all we can do as painters is to create impressions of them in our paintings. Leave the serious study of tree forms to the arbriologists. They do, however, fall into two most noticeable types: deciduous and coniferous, with many varieties of each, and further variations according to the season.

Coniferous trees

These are by far the hardest trees to paint. The example shown of painting a pine forest is worth trying to master as you will see this fairly often and can use it to separate middle grounds from foregrounds. The light trees in the background are painted first, the darker tree forms added later.

Deciduous trees

These are by far the most common trees and, incidentally, the easiest to paint. Each tree has a different overall shape, colour and pattern to its branch construction. Below are three very typical tree shapes. The pattern of the branches in winter is shown together with their summer foliage which you can create with the edge of your brush. There is not room here to show all the deciduous trees you will see so use sketches and photographs for your own reference to paint from when you cannot get outside.

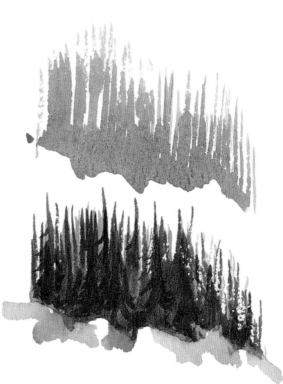

▲ *Distant coniferous trees look better if you make them appear to sit on rocky ground, Don't try to paint individual trees.*

▶ *Notice how the top branches of this Scots pine actually start halfway down the tree, and the foliage looks suspended in them.*

▶ *These illustrations of some typical deciduous tree shapes show their winter skeleton and their summer foliage.*

Seasonal trees

The techniques that are used for painting trees in the distance do not really vary with the changing seasons, apart from the change in the colour of the foliage. The extra detail you see and will want to show with foreground trees requires two very different approaches: one for winter and one for summer. To most novice painters, trees often present a huge problem. However, with a bit of observation and practice you will soon learn how to make the most of them. Few landscapes come without trees and the following exercises show you how to create them simply but effectively, no matter what the season. The more practice you get at painting different trees, the better and easier it will become.

Summer trees

Look carefully at a few trees before you start to paint. You can see that the foliage on many of them looks rather like a field mushroom which has been cut through in half. To create effective trees, you can try using the basic shape shown in the example below. You can also experiment with some different tree shapes. The colour of the leaves will vary throughout the summer months so you must expect to have to mix plenty of greens.

1 First, mix a wash of Raw Sienna with Hookers Green. Create an interlocking area of these mushroom shapes using the brush on its heel. Your mind will try to get you to make it ordered and symmetrical – fight it! Otherwise, your trees will look like bears climbing trees!

2 Decide where your light is coming from. Add French Ultramarine to your wash and then paint in the shadow sides and underneath the areas of foliage. This is best done before the paint is totally dry.

3 Add the trunk and branches with a wash of Burnt Umber, leaving gaps so the foliage appears to be in front of the trunks. While wet, add a touch of French Ultramarine to vary the colour inside the tree. Add the shadows with the same wash. The shadow always goes on both sides of the main trunk. Lastly, add a post or two.

Winter trees

Winter trees can be quite a challenge to paint, not least because all the branches need painting in. The method I use is to paint the main trunk and branches first, and then I pencil in the overall tree shape and mark the centre of this with a cross. Don't worry about all the pencil lines – they will erase when the painting is dry. A friend of mine who is an arborist thinks that these trees are wrong but, as I tell him, I sell more of them than he does!

Top tip

You only ever use the tip of the rigger, and keeping it at even pressure is difficult. To overcome this, use your knuckle as a support so the pressure and line remain constant. If your lines appear uneven, check whether the point has become worn; if so, save this brush for putting on masking fluid. If you're not used to using a rigger, try it out on a scrap of paper first. If you find it difficult, turn it upside-down, especially if you are left-handed. The bottom branches will always turn up at the ends.

1 *First, create your framework using Burnt Umber. Add a little Prussian Blue to this and paint the ivy. Next add a patch of dead grass with Yellow Ochre and enjoy a quick etch with your brush handle.*

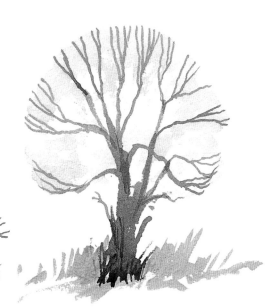

2 *Draw in the shape of the tree with a pencil and mark the centre with a cross. Using your rigger, paint the smaller tracery of branches. It matters not where you start; just paint them as if they started at the cross and then travelled to the outside edge. Make every line end on the pencil line; this will create your tree shape.*

3 *When dry, using your mop on its edge, add a little dirty water for the small areas of twigs. How is it looking? The more trees you look at, the better they will get.*

Adding the Details

In many respects, this is a misnomer to painters. The word 'detail' suggests lots of lines and fuss but nothing could be further from the truth. Your painting should not look like a photograph and the detail is often an illusion!

Light and shadows

Most beginners learn to paint from photographs and strive to make their paintings look as much like them as possible, but the trick with detail in a successful painting is not to paint any; it should be only a suggestion of what is there. The easiest way to do this is to use shadows to suggest shapes and forms on simple colour bases.

Try painting lots of simple coloured shapes and adding shadows to them or around them. You will soon discover that a great deal can be achieved with very simple brushwork. The more you do, the more skillful you will become!

▲ *You can create buildings from coloured shapes. A few simple roof shapes can look spectacular.*

▼ **Royal Pavilion, Brighton**
38 x 56 cm (15 x 22 in)
For such a complex building, the detail is minimal. The overall effect is created with shadows.

Bricks and stone

Buildings always present the painter with a challenge. They may be constructed from thousands of bricks and stones or, worse still, from concrete. I tell my students that although there may be 230,017 bricks in a wall, you can get away with painting only 40 of them. Not only will it look better but you might have it finished before supper!

1 *When you are painting brickwork, put a basic wash of colour over the wall.*

2 *Paint stronger coloured shapes of bricks in random patterns over this.*

3 *Simply tease them around with a damp brush, and they will look like perfect brickwork.*

Stonework

If the stonework is trimmed, paint it like the brickwork; if it is loose, as in a dry stone wall, paint it as shown in the example below.

1 *Paint a coloured base for the wall, making it much darker at the bottom.*

2 *Etch the stones into the wall in the usual way with a brush handle (see page 21).*

3 *A few darker areas of shadow will help to create a perfect stone wall.*

▲ *Alternatively, lay the colour down and draw into it with a water-soluble pencil. This is easier to do and creates a smoother stone effect.*

Windows and doorways

Painting buildings will always involve doorways and windows. These can be quite tricky to paint so practise drawing a few first to learn how they look and how their shapes change when viewed from various angles. There is no such thing as a typical window, but they do all have one thing in common – glass – and this must be painted well to work effectively.

Sash windows

In a sash window, the top section is usually in front of the bottom one. When painting this, show the different thicknesses of the timbers, and how the glazing bars are offset in the lower window.

▼ *With windows, the easiest way to keep the glazing bars is to mask them with fluid. The glass can then be painted simply but boldly with washes over washes. All you are painting is the reflection in the glass itself. Remove the masking before adding the shadows!*

▲ *The timbers in the window frame were masked out as white. The basic blue of the glass was added and, when dry, the reflections were painted in. You will see all kinds of shapes reflected in glass, and it is often best to look through sunglasses to help you identify them.*

Doorways

Even a plain door can enhance a painting. You can make it whatever you like – old or new and bright, with or without steps or with a boot cleaner, perhaps. Try experimenting with various types of doorways; practice will make perfect.

▲ *When you look at a door straight on you will see the frame all around it. However, when it is viewed from an angle the first part of the door will usually disappear behind the brickwork.*

Top tip

Polished metals and glass reflect light and other objects. Outdoors, they reflect their environment; indoors, place a few bright strips of coloured paper nearby to make reflections appear in them. Add a basic wash colour (blue for glass, pale orange for brass) and paint the reflections over this.

Larger doorways

The illustration below shows what can be achieved with a pair of large doors. Garage, workshop or barn doors all offer an opportunity to open them up and play around inside – an effective way of attracting the viewer's eye.

▼ *A window at the back creates light; some loose, coloured areas becomes a piece of farm machinery (a 'pig mincer') enabling you to make better use of shadows.*

Textures and materials

You can have fun experimenting with painting a variety of surfaces and textures. There is no fixed way of doing this and you may need to plan a wash over another wash, using masking fluid or candle wax (see page 22). Another technique is to lay a wash, then cover it in cling film for a cracked effect. Try out different ideas, keeping all your workings for future reference. What seems less effective today may actually become a way of creating another effect in the future.

Painting rust

To make materials and buildings look old and moody, you can add some rust. This sounds quite difficult but in practice, it's very simple and you will soon master the technique shown below.

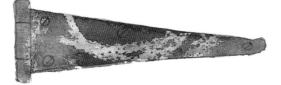

1 Paint the metal first in a rusty mix of colours. Don't worry if the odd watermark appears; it will add to the finished effect.

2 Add some candle wax to this, then lay the darker colour over it. The wax will resist the paint and the metal will look effectively rusty.

Wood grain

You can see the grain pattern in wood when it is cut and planed. There are three basic ways of creating the effect of wood grain.

▲ Etch the grain pattern into the wet paint with a brush handle.

▲ Apply some wax over the first wash, and then add a second wash over the wax.

▲ Apply masking fluid over the first wash, when dry. Then add a second wash to reveal the lighter wash underneath. This gives a more controlled effect.

▶ Use a brush handle to etch the texture of bark into an old tree. Simply paint the tree in some dark wet colour and then etch in the lines for the bark.

Other ways to add detail

There is no such thing as a correct way or time to add detail to a painting. It can be added at virtually any stage, especially using etching techniques into wet paint. However, these have to be done immediately as re-wetting and then trying to etch doesn't work.

All the details can be added in Stage 6 (see page 50), with shadow in Stage 7 (see page 52) or when everything is dry, using ink or a touch of pencil or pastel. Simplicity is the key.

▶ **Haute Bois Church, Norfolk**
30 x 20 cm (12 x 8 in)
A ruined church offers you plenty of textures and forms. I painted the stonework, then etched the wet tower and painted the porchway, walls and gravestones. I drew into these whilst still wet with a watersoluble pencil.

◀ **The Customs House, King's Lynn**
28 x 38 cm (11 x 15 in)
This atmospheric study is further enhanced by painting the subject simply and adding the foreground buildings and details in ink over the watercolour. The background is left undefined, thereby creating a sense of distance and depth.

89

Creating Shadows

There are many accepted ways of shading a painting but no set rules. It all depends on how you structure your painting. Because I always use my seven-stage method, my shadows go in last. This way, the edges of the shadows don't get washed out and remain sharp. For a watercolour to look sunny and bright, you need sharp-edged shadows.

Placing shadows

Shadows make your paintings three-dimensional. In landscapes, the main light source always comes from one direction so place all the shadows at the same time. In this way, a wash of consistent strength and hue can be used.

▲ *Shadows can make or break a painting. You need to study many buildings on sunny days to become knowledgeable. They are very effective when crossing space and falling onto other buildings. Notice how the shadow of the house on the right bends over the walls and roof of the building on the left.*

▼ Place de Valldemossa, Majorca
28 x 38 cm (11 x 15 in)
Shadows from trees across a street or alley help to create drama and distance in your paintings as well as showing the direction of the light.

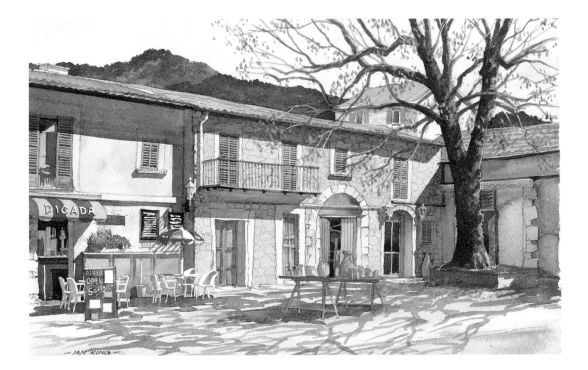

Shadows in landscapes

As with buildings, shadows in landscapes increase the recession effect. Any device that allows you to create light and dark bands across a foreground is worth using. On many occasions, I change the light direction completely to make this happen. Very often the shadows in a landscape will be created by trees, and these shadows will vary with the season.

▲ Norfolk Farmland

28 x 38 cm (11 x 15 in)

The light here is coming from the north but I wanted a warm feel to the foreground to create depth so I moved the sun round 180 degrees. The shadows falling down the banks and into the ruts help create the flow of the landscape. A flash of shadow across a foreground is often enough to make a background work.

▶ *Shadows under summer trees can be very dark. This shadow is not only below the tree but extends beyond it. It is best painted all in one go with nervous lines wet into wet. Never go back into the wet paint to touch it up or you will have ugly watermarks.*

▶ *Shadows cast by winter trees are usually quite pale as lots of light comes through the trees. They are always quite linear as they repeat the shapes of the branches. Remember to shade the shadows of the branches on the trunk.*

Changing direction

Planning a painting works – you will already have discovered that. However, taking this a stage further by changing the direction of the light in your paintings can improve them dramatically. Using your original drawing, trace it through a few times onto some cartridge paper and see how placing the shadows in different positions will make or, possibly, break it. I have included some quick sketches to show how changing the light can transform a simple street. I have added extra trees to make more shadows available or create counterchange.

Whenever you paint a street or lane, try out the little exercise below which only takes a few minutes. You could simply indicate the shadows in pencil if wished. You can learn a lot about light from these studies. They will help you determine the way that shadows fall from and on to roofs and buildings, and that in itself will save you from many a looming disaster.

▶ *The light appears to come from the left front of the painting. It leaves the fronts of the three cottages dark and the two on the right light. Placing a large tree behind the two light walls and a tree in the front at the right enhances the view greatly.*

◀ *Shading the painting from the left from the back takes most of the light out of it. The shadows don't work well and the counterchange is not effective.*

▶ *The light coming from the right front does little to show the forms of the cottages. Chimney stacks get lost, and the overall subject looks flat. Shadows help to create a three-dimensional painting.*

◀ *With the light from the right back the two nearest cottages become dark and much of the light in the painting is lost. The cottages on the left look interesting and brighten the painting but they don't work as well as the first study above.*

Other types of shadow

The process of shading is usually straightforward, but there are some occasions when the colour of the shadows will be affected by the weather or the subject, most noticeably when large areas of white remain in a painting. Weatherboarding, mills, windmills, lighthouses and snow scenes all require a change from normal shading.

The mix needs to be mauve rather than the normal landscape greys of Burnt Umber and French Ultramarine, or the architectural greys: Burnt Sienna with French Ultramarine. A grey shadow across white looks dirty and flat whereas a mauve shadow gives warmth and light.

In some situations, the white in the subject will reflect light back and this will change the appearance of the darks.

In snow scenes, as we have already mentioned, there will always be some Raw Sienna in the sky as the light is reflected back into it from the snow on the ground.

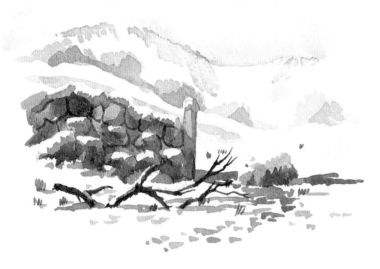

◀ **Shadows in Snow**

To create effective shadows in snow you need to draw the subject lightly in pencil first, then imagine the surfaces where the snow would settle, the ground looks after itself as this is left as white paper, use masking fluid to mask the snow on solid forms. The subject is painted as normal and when dry the masking is removed. The magic happens when the shadows are added, A few footprints in the foreground always work well here.

▶ **Church Street, Rye, Sussex**

38 x 56 cm (15 x 22 in)
Here is a classic example of how reflected light lightens a wall in the shade. The shadows are all as you would expect except for the wall on the right which is almost as light as the wall on the other side of the street. All I put over it was a very weak wash of French Ultramarine. This cooled it slightly without losing any of the reflected light.

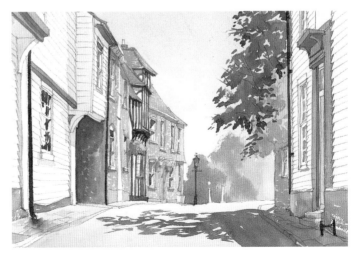

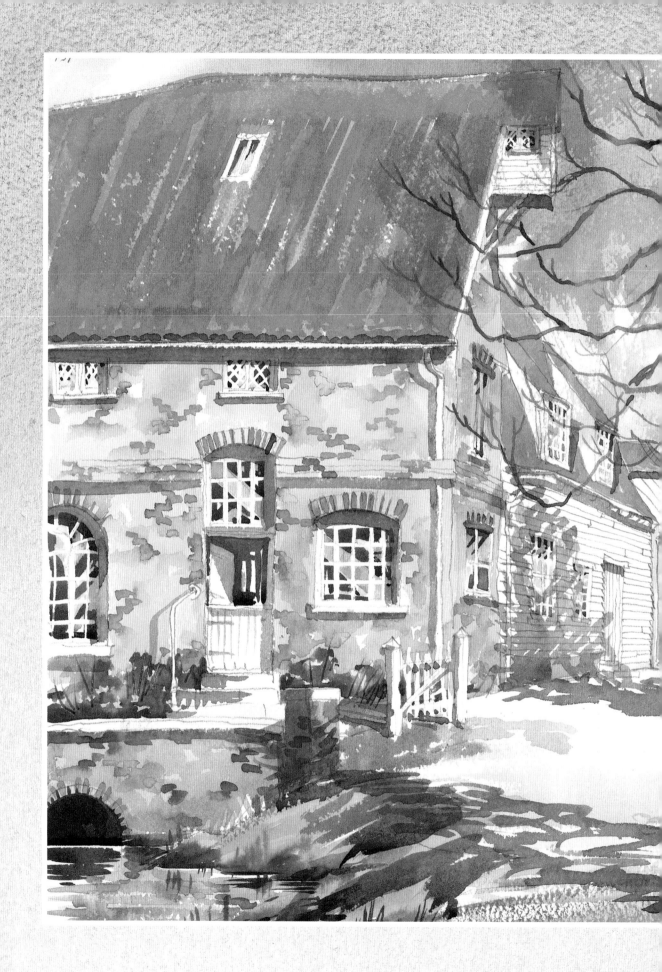

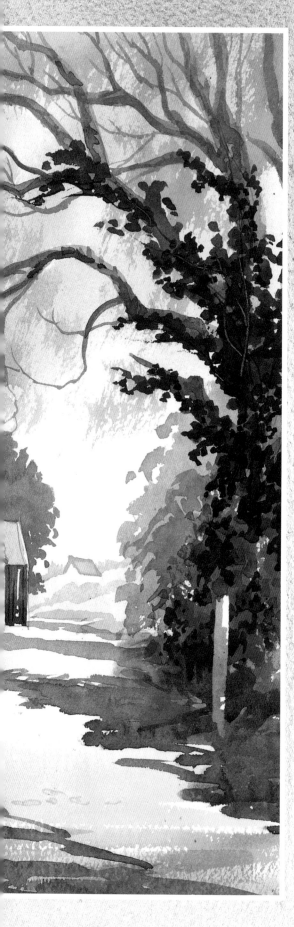

The next step

In the previous sections of this book, we have been looking at how to develop your basic watercolour techniques. By now, you will realize that good painting needs to be structured and can be broken down into the seven basic stages. I have spoken about colour being your alphabet and brushwork your language, but now it's time to get painting and add some slightly more difficult subjects to your repertoire – water, always a challenge, and figures, which provide interest in a picture. Finally, there are four step-by-step demonstrations to help you put all you have learned into practice. Now you can begin to really enjoy your painting.

◄ Flatford Mill, Suffolk

38 x 39 cm (15 x 15¹/₂ in)

I planned my painting to look up the lane rather than focusing on the mill. This enabled me to contrast the earth colours in the architecture with the deep greens of the hedgerow and pool. The morning light casts shadows across the lane to create depth.

Painting Water

Learning to paint water, moving or still, enables you to expand your range of subjects to include virtually any landscape. Still water, such as estuaries, lakes and puddles, may be painted or even left as white paper if you are close to the subject, but you will usually have to paint moving water, too, including waterfalls, streams and the sea.

How best to paint it

The horizon behind the water must be flat. Paint the sky, ensuring a level base by using masking tape or painting along a line drawn across the paper. Leave a gap between water and sky to separate them. Distance is created with dark and light bands. Painting these at the normal angle will cause the bands to sag but turning your board on its side will make any runs vertical and, when returned to the upright position, horizontal.

▲ *Wet the area you want to be light, then wash some blue all over what will be the water. The same applies if painting the water light and adding a dark streak.*

▼ **Maggiore St Giorgio, Venice**
19 x 38 cm (7 x 15 in)
Looking into the sun, the only reflections here are from the gondolas in the foreground.

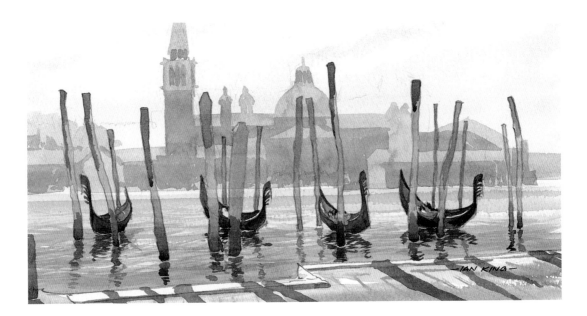

Painting the water or not

Whatever goes above goes below, or does it? Let's look at two watercolours which both use the same drag technique for creating reflections. In one, *Autumn on the Broads*, the water is painted. However, in the other picture, *Thornham Sluice*, where the viewer is much closer to the water's edge, the water is left as white paper to create a brilliant, glossy feel. The appearance of the light in the water is strikingly different in each of these paintings.

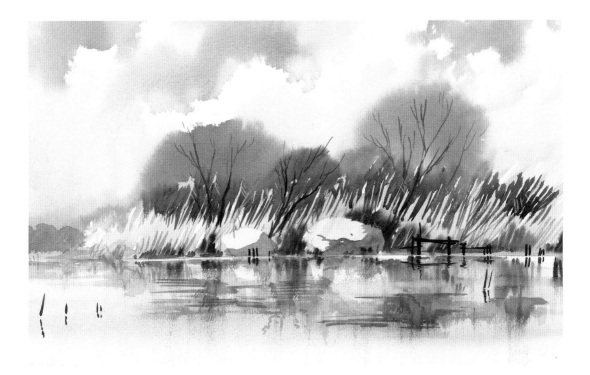

▲ Autumn on the Broads

38 x 56 cm (15 x 22 in)
A wet area was brushed through the centre, then a wash of Cobalt Blue was added, and a pale wash of French Ultramarine to the foreground.

▶ Thornham Sluice

38 x 56 cm (15 x 22 in)
The sky was painted to the top of the banks. Pale greens make up the distance. Reflections were added by dragging down the paint with a thumb.

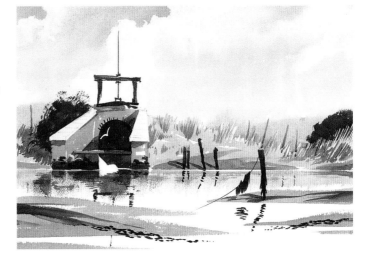

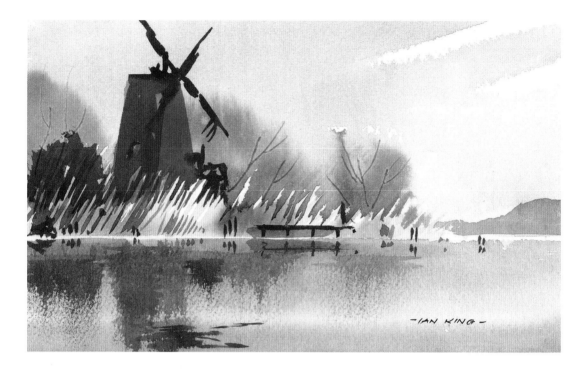

Reflections in still water

One of the simplest ways of adding reflections in still water is to simply paint the colour on and then drag it down with the edge of your thumb.

Masking fluid for reflections

Masking fluid can be used to save colour as well as white paper. However, always make sure that the paint is dry before adding each layer of fluid or it will soak into the paper and you won't be able to remove it.

▶ The Welle Creek, Cambridgeshire

34 x 32 cm (13 x 12 in)

I painted the reeds in a block of pale Raw Sienna with a little in the water below. When dry, I painted some of the reeds with masking fluid, using an old rigger, and added some reflections, then left it to dry. In this way, I built up three layers of different colour reeds, protected by the masking fluid.

▲ A Broadland Windmill

16 x 26 cm (6 x 10 in)

This study of a mill and its reflections shows the effect of a wet streak through water painted on its edge. If this had been allowed to run down and sagged, the effect would have been ruined.

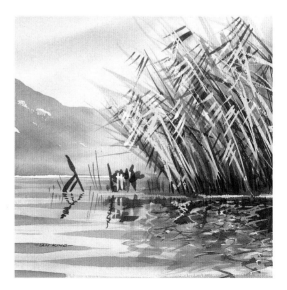

Painting puddles

Usually the water in puddles is left uncoloured as white paper. This is because the detailed part of the painting is usually quite close to you and therefore the water needs to stay bright in order to work well.

The far edge of each puddle must be flat or it will appear to be going uphill. As water always finds its own level this would obviously look wrong, even when viewing a subject from a higher vantage point. Any reflections will always be a 'mirror image' of what is above the puddles. Objects that lean to the left in reality will lean to the left in the reflection, and vice versa. Usually there is no need to drag the reflections; just paint them in accurately with sharp edges.

Before you start painting, make a quick pencil sketch to indicate where the puddles are going to lie, making sure their far sides are flat.

▲ *This simple study shows how a mirror image of the grasses is reflected in the puddle below.*

▲ *Only the sky is reflected here in these puddles in a ploughed field. Note that the background is too far away and not sufficiently detailed to be reflected.*

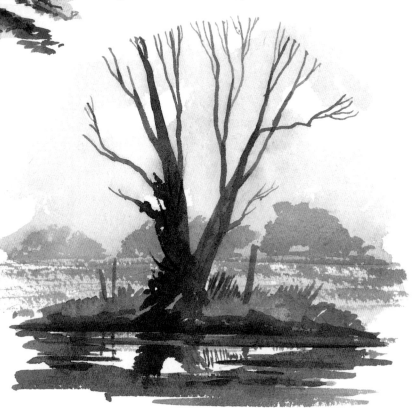

▶ *This atmospheric study was made at the entrance to some fields near my studio. It had recently rained, everything was wet and the puddles were quite full.*

Painting rivers

In moving water, the reflected light also moves, affecting the sky, solid masses, such as bridges, and natural objects, such as grasses and trees. There will be no visual mirror image – merely an array of colours blended together.

Moving water is often better painted quickly as in the examples shown here of the same subject. One view is a classic watercolour while the other is an ink and watercolour treatment. I sketched in the bridge, arches, banks and some of the main trees and boulders with ink, then painted the background hills and trees loosely, adding some of this colour in wavy stripes to the reflections. The earth colours of the bridge were also used in its reflection. There was still lots of white paper left in the water and I managed to keep a lot of it as I painted the sky in pale Cobalt Blue and added stripes of it to the water.

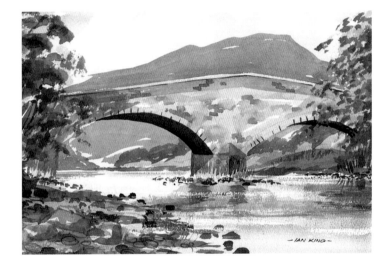

◄ Ouse Bridge in Summer

22 x 37 cm (8 x 14 in)

The reflections of the bridge and trees were painted loosely to create the sense of movement in the river below. Candle wax was drawn across to create the ripples.

▶ Ouse Bridge in Winter

26 x 35 cm (10 x 14 in)

A change of technique can add vibrancy and contrast to your work, as shown here by the use of black ink to define the arches of the bridge and the tree trunks. I left lots of white paper in the water, adding wavy stripes of Cobalt Blue to reflect the sky colour.

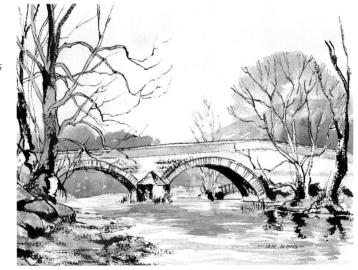

Streams and waterfalls

These are very much a 'sketchy' type of subject; the looser the treatment the better and more effective the finished painting. In the example shown here, I sketched the subject and then re-drew it again simply to give me a good understanding of what I was trying to paint.

I masked the white areas I needed with masking fluid, washed all the colour areas in, outlined them in pencil, then masked my light areas again and added the darks. Without a clear understanding of the subject, this would have been a nightmare lack of planning. You only need to look at some of Turner's working sketches to see this, but remember that your sketch is only a working drawing – not a work of art!

▶ **The Waterfall at Higham Hall**
22 x 19 cm (8 x 7 in)
The small sketch (above) shows the detail that I needed to be able to plan the watercolour (right). It really is necessary to do this first if you are going to succeed. Simply by making the sketch you will have had to look closely at your subject; this observation is far more important than the quality of the finished sketch.

Top tip

When painting ripples, use a straight edge held slightly off your paper. Run the brush along the straight edge, varying the pressure to create thick and thin lines. Try this out on a scrap of paper first. I always use a No. 8 round brush; it may look big but it works well.

After transferring your sketch to watercolour paper, mask out the whites. Do this minimally as too much masking fluid can actually spoil a painting. Only remove the masking fluid when the painting is dry and before you add the shadows. You can add a little sparkle to the waterfall, if wished, by lifting out some vertical lights with a sharp blade.

Using the technique of drawing over your paint will make a subject like this not only easier but usually more fresh when completed.

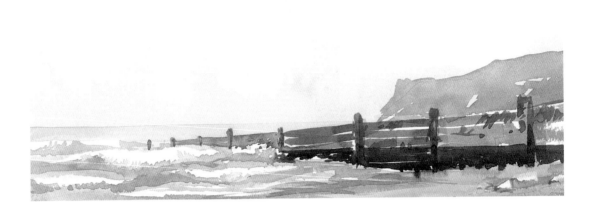

Creating waves and sea

Before you even attempt to paint the sea you need to look closely at it. Have a look at some paintings or photographs as a still reference to enable you to study the shapes of the waves properly. Essentially they are white spaces with shadows and can be created using a wide variety of techniques. You can lift them out, using some tissue in wet paint or draw around them and painting around the white areas to keep the shapes intact. Alternatively, mask them out with masking fluid or add them in body colour. If lifting out, always use a wood pulp paper, such

▼ *Paint the sea with Raw Sienna and French Ultramarine. Paint around the whites of the waves or blot with tissue folded to make a long edge. Add darker colour to the water under the waves. When dry, add some shadows to the white foaming water.*

▲ A Beach and Groyne
15 x 37 cm (6 x 14 in)
The waves were created by painting around them and then picking out the spray with a knife.

as Bockingford. Plan the waves carefully – they are all you have to show distance – and try to keep them horizontal. For the finer spray, scratch it out with a sharp blade once dry.

As an exercise, draw a simple groyne. Mark in your horizon, add a simple sky and then paint in the sea, painting around the white waves or blotting them out. Add a simple background of cliffs and a beach with a combination of earth colours. Slightly cover the sand at the front with the sea wash. Etch this with a brush handle to form pebbles. Paint in the groyne with differing strengths of Burnt Umber and add some seaweed. Add the shadows to the waves with a mixture of Burnt Umber and Cobalt Blue.

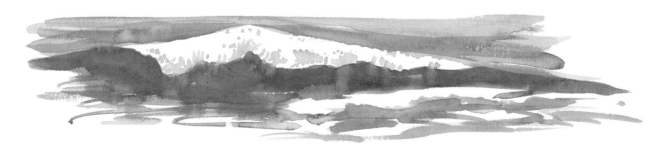

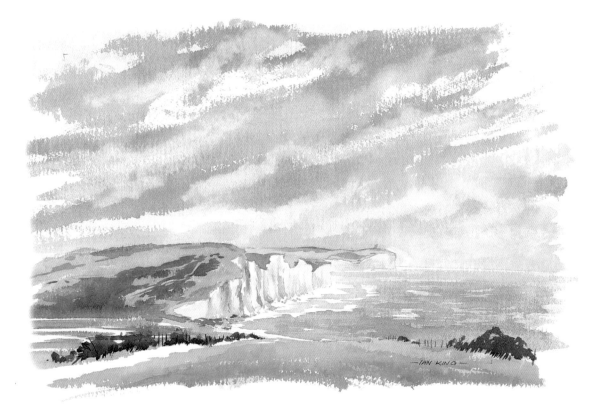

▲ The Seven Sisters, Sussex

38 x 56 cm (15 x 22 in)

If the sea is stretching away in front of you, vary the colours. The white water can be masked out, but to have recession the sea colour needs to change in horizontal bands into the distance.

▼ *Water at sea is painted layer on layer. Wash Raw Sienna and Cobalt Blue from the horizon to the front. Let each layer dry before adding the next. Leave gaps for light in the water. Add French Ultramarine to each layer to bring the waves forward. When dry, scratch out the crests or use white gouache with your finger.*

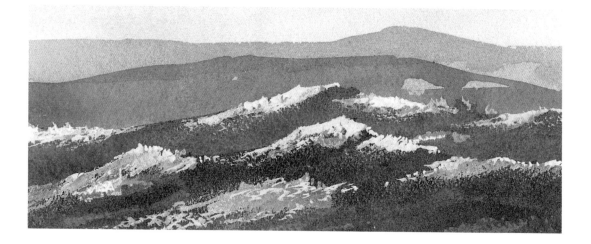

Painting boats

As tides flow in and out, the water in a harbour is never still. There's always movement and you can show this by painting the reflections in shapes that are similar to those of the boats themselves; it's as simple as that. The more the shapes move, the more the reflections will appear to move. Here's a basic step-by-step guide to painting a boat and its reflection.

1 *To draw a boat, start with an extended figure of eight, then add a 'wine glass' to the stern. Mark in the front and add some planks but don't join them – leave a gap in the middle.*

2 *Paint a simple outline of the subject. Do this by brushing with a pale wash of Cobalt Blue.*

3 *The water level should be slightly above a third of the way up the boat for the reflections to work. Complete the boat and figure, adding Burnt Sienna for the stern and thwart, and Cobalt Blue at the base. Add the reflections, leaving a white gap in between.*

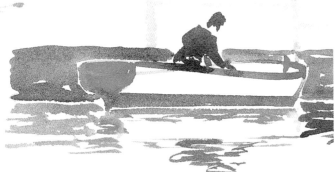

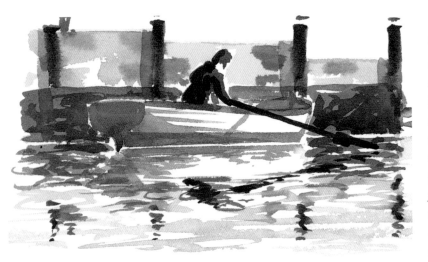

4 *Indicate the jetty and add some wavy reflections. Leave a gap for the water's edge on the wall. Paint the stonework in Raw Sienna. Drag some Burnt Umber across for the larger stones, adding the reflections. Leave some white under the boat. Add the timbers, then add some wavy reflections. For distance, paint in a pale watery wash behind the jetty. Use the shadows of the posts on the wall to give dimension. Paint the reflections of the shadows and the water in wavy figure-of-eight shapes.*

Distant boats

The easiest way to show distant boats is to paint your subject, complete with its background and foreground, then make a paper stencil and lift out the features you want. Extra colour can then be added to the lifted out subjects if necessary.

Remember that a large part of a floating boat is under the water and this is how it needs to look in your paintings. If a boat has a large bow wave it is because it is ploughing through the waves. Always make a boat look as if it is floating in water and not in air.

▶ *The boats and lighthouse were lifted out with a stencil and damp sponge after the watercolour dried.*

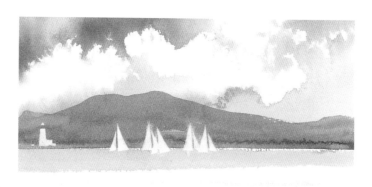

▼ **Thames Barge off Maplin**
16 x 22 cm (6 x 8 in)
The sails were painted bright against a broken grey windy sky to make the vessel look as if it is catching rays of sunlight coming through the clouds.

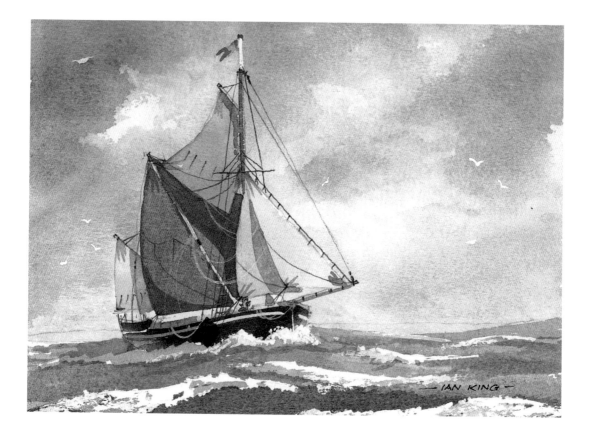

Figures in Painting

The idea of painting people can be frightening for many painters, especially novices, and this deters them from ever attempting to add the odd figure into a subject. But as we will see, figures can have a very beneficial effect on an otherwise quite ordinary subject.

How to use figures

Figures can be used to show scale and depth and can draw the viewer's eye into the back of a painting. Often it will be simply a fun subject, an attempt to paint the impossible, or what may have been dismissed as being impossible. A few figures can create a striking subject which you would never have thought possible. Painting a town square, a railway station or a view where there are crowds is a daunting prospect, but it's the use of figures that makes those kinds of subjects achievable. Many years ago, as a struggling art teacher, I tried to get youngsters to include figures in their paintings and, of course, they were totally intimidated. But I found a solution to painting figures that worked, and now I pass it on to you.

Ms and Ws

To create a good balanced figure, all you need to paint is an 'M' and underneath a symmetrical 'W'. Add a pair of shoulders and some hair – you do not need to fuss over faces – a pair of arms and fill in the gaps. You will have a simple figure. With practice, you can create any shape you want. As long as the Ms and Ws are in proportion it will work. You can paint them in very light paint and then add the clothing later if you wish. By altering the angles of the Ms and Ws you can even create figures in totally different poses.

▼ From a simple M and W a huge range of figures can be created. Gaps for faces will make them face forward; solid hair shapes backward. Vary the size of the Ms and Ws for larger people!

106

◄ *It is best not to try to add feet to your figures or they usually end up resembling Charlie Chaplin and never look as if they are actually on the ground.*

▲ *Simply by having a right angle in the M and W, a seated figure can be painted with one leg bent which will give it balance.*

▲ *When you want figures against a background, paint the figures first in light paint. Add the background and then finish the figures so that the paint slightly overlaps. This makes the figures appear in front of the subject.*

◄ *Paint the M and W in very pale paint if you want to have light clothing as in the French waiter here. I have added the lines over to help you see the Ms and Ws.*

Top tip

How do you decide on whether to paint a figure or not? Heathcote has lived in my watercolour box for years. When I need to make a decision as to whether a figure would make a watercolour work better or not out he comes. Simply by holding him in the painting I can tell immediately. This is a lot safer than painting a figure in and hoping for the best – Heathcote is much easier to remove. You could keep a couple of figures handy in two different sizes – one for your backgrounds and the other for foregrounds.

Using figures to show scale

You can use figures to add a sense of scale to your pictures. Both the arches illustrated (right) were identical in appearance until the figures were placed in them. You can see that the arch on the left becomes a grand entrance whereas the arch on the right becomes no more than a passageway. It's amazing the effect that a single figure can create, isn't it?

Deciding how large a figure needs to be can be a problem but not if you adopt this simple solution. In the painting below I have used three identical-sized figures and have placed each one at a different level. You will soon see which figure looks correct and which ones are either too large or too small.

▲ *Draw the same sized arch twice and then practise adding figures of different sizes to see how they can affect the sense of scale of the archway.*

▼ *Paint a figure on a scrap of paper, cut around it and then try placing it in different positions on your painting. You will soon see where it looks the right size – in this case, the figure on the left.*

Figures in a landscape

The size of figures in a painting can also be used to indicate scale. A couple of very small figures can help to make a landscape appear larger in scale and more vast, whereas using larger figures can cause the background to appear nearer to the viewer. This is because we can all relate to the size of people and our interpretation of scale of a particular subject comes from this.

▲ Estuary with Figures
30 x 50 cm (12 x 20 in)
The addition of two very small figures walking on the shore helps to make the estuary look vast in this atmospheric painting.

▶ A Walk on the Beach
35 x 45 cm (14 x 18 in)
The larger couple here shown strolling along the beach make the cliffs behind the seascape appear to be quite close to the viewer.

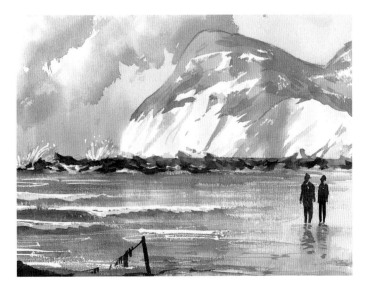

The dynamic effect

Figures can add dynamism to a painting and perform several key functions. They can be used to show scale, to help draw the viewer's eye into the painting and to greatly enhance the work that is performed by shadows. They can also create the 'Giles effect', following on from that great cartoonist who always drew some extra fascinating little detail in a corner which made you look again.

We all like looking at people, especially when they are doing something. It may be a single figure, an intimate conversation or a group activity. Whatever it is, it will add interest to your paintings. Your figures will always look better in the background if they are walking into the distance or if they are stationary and conversing with each other. They will never look right if they are walking out of a background towards the viewer; it is almost as if you expect them to get nearer but they never do.

◄ **Calle del Tagiapiera, Venice**
34 x 16 cm (13 x 6 in)
The very quick sketch made on a hot afternoon in Venice makes use of a young girl with her shopping who is entering the shadow of an arch with a light square behind. The eye is drawn into the back of the subject simply by the addition of an M and W figure. Without it, the subject would have had little depth or feeling. The dark figure helps create the feeling of it being hot – and it was!

Figures in perspective

People as a subject can be a challenge and the trick is to make them appear in perspective. This, at first, may seem quite difficult but if you line all the figures up at the same point it becomes easy. The level will always be at your own eye level. Try varying the sizes of the figures across your paintings – for instance, some could be facing each other in conversation, some standing, some walking, some carrying goods or bags. Experiment with adding children to create interest, although they will be smaller and will be lined up with the feet of the nearest adult.

To paint a group of figures that looks part of a subject and works within the perspective, you simply have to paint them all with the join between the Ms and Ws at the same level. No matter what the size of the figures, they will look right in a background as long as the Ms and Ws are in proportion to each other. The view point for the perspective will always be at the same level as the point where the M and W figures join. This becomes your eye level.

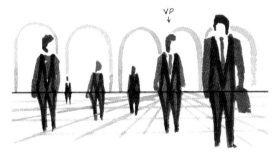

▲ *Before starting to paint, make a pencil sketch or plan out your painting, placing your figures first and then adding the background.*

▼ *In this quick watercolour of a busy railway station, the Ms and Ws were painted in a very light wash with all the figures' hips lining up at the same level. The eye level of the perspective is also at the same level. After painting the figures, you can add the details, background and shadows. Although painted quickly, it captures the feel of a busy railway station.*

Demo 1: Majorcan Monastery

Holidays can present you with lots of opportunities to paint. This view of an old monastery had me reaching for my paints before the car had even stopped. But remember that a painting has to be planned carefully if it`s going to succeed.

Size: 28 x 38 cm (11 x 15 in) **Paper:** Arches 140 lb Not
Brushes: No. 2 round, No. 6 round, No. 10 round, No. 4 mop

Palette:

| Raw Sienna | Yellow Ochre | Naples Yellow | Burnt Sienna | Burnt Umber | Alizarin Crimson | French Ultramarine | Prussian Blue | Cobalt Blue | Coeruleum |

◀ Planning stage

Firstly, as you learnt on page 35, you need to make a sketch and establish the focal plane. If you wish to mask light poles and trees and the tower of the monastery, do it now with some masking fluid. That way, you can keep your small white lines whilst you lay larger washes over the painting.

▶ Stage 1: the sky

Turn the painting upside-down to keep the foreground clean. Wash the entire area above the focal plane with clean water, then add Coeruleum at the horizon and Cobalt Blue at the top of the sky. Quickly wipe a couple of streaks of cirrus clouds out of the sky and then blot a couple of light patches where the background hills will be painted. Allow to dry thoroughly before moving on to stage 2.

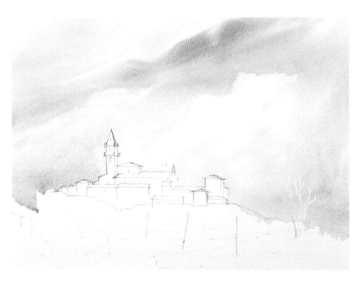

◀ Painting around the rooflines is easier with the painting upside-down to stop the colour running.

▶ Stage 2: the background

Mix Raw Sienna with Alizarin Crimson to create the rock colour, and lay this over the sky for the hills. Whilst wet, add a mix of Raw Sienna and French Ultramarine for the trees. At the top of the hills, add a few trees, using the edge of the brush to make the skyline. These will be over dry sky and will have harder edges. Finally, add a little of the tree wash to begin to show the trees on the left. Keep some of this wash for stage 3.

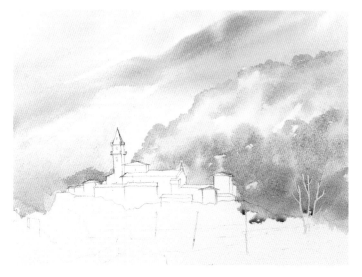

◀ *Use the edge of the brush to add some trees on top of the hills and thereby create the skyline.*

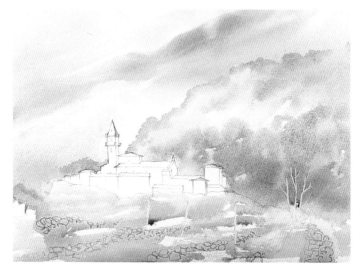

▶ *With the tip of the brush handle, etch the wet paint to create the stony terraces and boulders.*

◀ Stage 3: the foreground

Paint a wash of Raw Sienna in the middle ground under the monastery. Keep it brushy – it needs to look like a painting. Add a wash of Yellow Ochre to the foreground, then stripes of the tree green in lines to show the almond trees leading the eye into the distance. Etch a few boulders and stones to indicate the terraces.

▶ **Stage 4: the main subject**

Remove any masking fluid from the buildings. Mix an opaque wash of Naples Yellow and Alizarin Crimson, and paint the monastery walls and terraces underneath. It should help make the architecture look solid against the background. If not, add more wash when it dries. Add a little Alizarin Crimson and use for the roofs. Vary the colour of some roofs by adding Burnt Umber. The tower roof is a mix of Raw Sienna and Coeruleum.

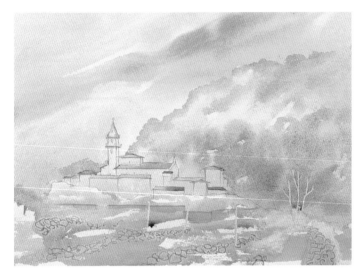

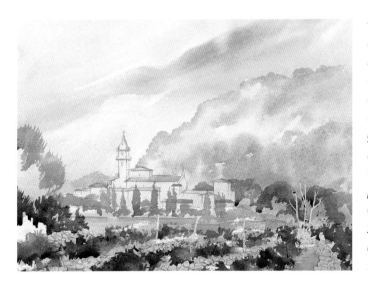

◀ **Stage 5: the trees**

Paint the background trees with a mixture of Raw Sienna and French Ultramarine. Leave some areas unpainted to look like lighter trees. Use the same wash for the almond groves (see detail, below left). Paint the middle-distance cypress trees and those on the left of your painting with a wash of Yellow Ochre, Prussian Blue and Burnt Sienna. Add more Yellow Ochre and Burnt Umber for the greens in the foreground.

▶ *Using the brush in a twisting motion, add the remaining Raw Sienna and French Ultramarine to create the almond groves in the foreground.*

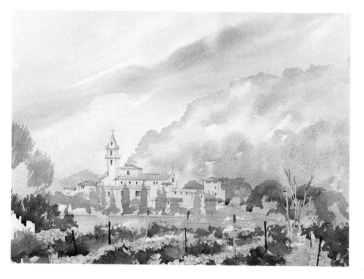

◀ Stage 6: the details

Remove the remaining masking fluid. Remember the monastery is in the distance so a few windows will be sufficient. Never use black. Instead, mix Burnt Umber with French Ultramarine, then paint them in and blot one or two to vary the colour. Add some posts in the foreground with the same wash. Paint the light poles and tree with Naples Yellow and Burnt Umber. Add the odd dark on the posts and tree with the dark wash.

▼ Stage 7: the shadows

Mix Burnt Sienna, French Ultramarine and Cobalt Blue for the shadow wash. The light is coming from the left, so shade the terraces and trees on the left on the right-hand sides. Paint the shadows of the trees and posts on the ground.

Add a little water and shade the architecture and terrace walls and the trees in the middle distance. Add more water and add gullies to the distant hills. When dry, mix the leftover paint with a little French Ultramarine. Add a flash of this over the immediate foreground.

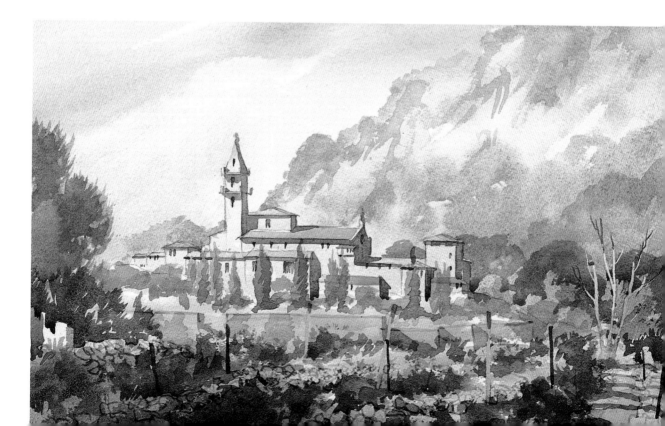

Demo 2: Old Stone Bridge

This is a subject that is very dear to my heart. I spent a great deal of my childhood playing on these very banks by Barden Bridge. I can only hope that you derive as much pleasure from painting this as I get from my memories of the place.

Size: 38 x 56 cm (15 x 22 in) **Paper:** Arches 140 lb Not
Brushes: No. 4 round, No. 6 round, No. 8 round, No. 10 round, No. 4 mop and rigger

Palette:

Raw Sienna | Burnt Sienna | Burnt Umber | Yellow Ochre | French Ultramarine | Prussian Blue | Cobalt Blue | Hooker's Green

◀ Planning stage

Make a sketch to determine the foreground, background and the focal plane. Position the bridge one-third of the way up your painting to give a large foreground. Place the tree about one-third of the way in from the right. Before you start to paint, add some candle wax to the water area to create the wind-blown ripples.

▶ Stage 1: the sky

Mix a wash of Cobalt Blue, and then a stronger wash of French Ultramarine. Turn the paper upside-down and, using your mop, wet the sky, background, under the bridge arches and water. Wash in the Cobalt Blue over the background and under the arches. Add streaks to the water. Turn the painting the right way up; blot out the clouds. Drop in the French Ultramarine, pushing it into the Cobalt Blue.

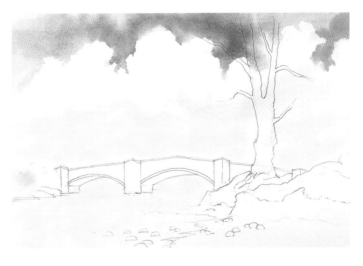

◀ *Carefully blot out the clouds with some tissue. Don't go too low or you will spoil the background.*

▶ Stage 2: the background

Mix a wash of Raw Sienna and French Ultramarine. Using a No. 10 round brush, paint the background hills, starting with the skyline. Leave some gaps to give the background more life. Wash some under the bridge arches and into the water to create the reflections. Add a little Burnt Sienna to the hills. Mix Burnt Umber and French Ultramarine, add to the rocky skyline, turn upside down and leave to dry.

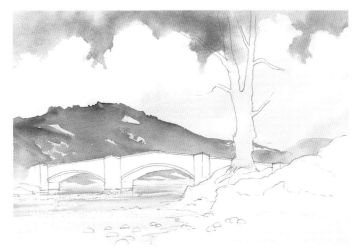

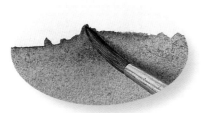

◀ Add the rocky outcrops with a No. 8 brush and a wash of Burnt Umber and French Ultramarine. With the painting upside down, the colour will run up to the dry sky and form a crisp edge.

▶ Stage 3: the foreground

Mix Raw Sienna and Hooker's Green for the banks. Add Raw Sienna and Burnt Umber to the right-hand bank. Lift out the boulders. Add deeper colour around the boulders and spread wet in wet. Wash in the far river bank with Raw Sienna and Hooker's Green. Add a little to the water and drag down to soften the edge. For the shingle, apply a wash of Raw Sienna. Add Burnt Sienna and Burnt Umber and spread. Etch in the pebbles and shingle.

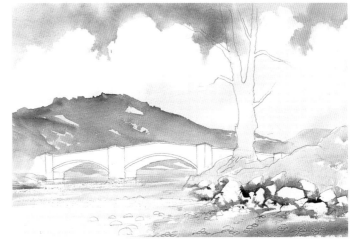

◀ Use your credit card to lift out the boulders before the paint dries.

▶ Stage 4: the main subject

Mix Raw Sienna and Burnt Umber and paint this over most of the stonework. Use it in the water for the reflections, dragging it down with your thumb. Whilst wet, add some random areas of Burnt Umber and French Ultramarine to the bridge. Using the same wash, add some of the boulders in the river and river bank.

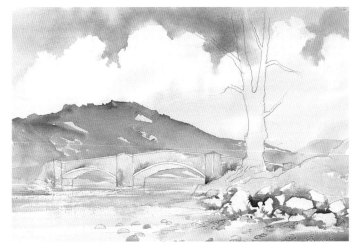

◀ *Drag the reflections down into the water with your thumb to create texture and movement.*

▶ Stage 5: the trees

Mix Yellow Ochre, Burnt Umber and Prussian Blue to paint the tree on the left. Add colour to the water below, dragging it down with your thumb. Paint the tree on the right and the one behind the bridge, adding reflections. Mix Raw Sienna and Hooker's Green for the large tree trunk and randomly add some Burnt Umber. With a rigger, add smaller twigs and branches and the grass on the right.

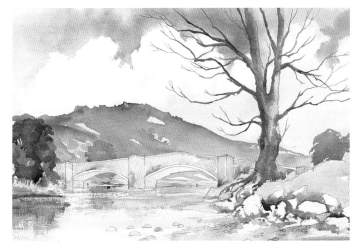

◀ *Use a rigger for the twigs and branches. If you don't feel confident, practise on a scrap of paper first. It will make or break your finished painting.*

▶ **Stage 6: the details**

Mix Raw Sienna and Burnt Umber for the stonework on the bridge. Using a No. 4 brush, paint in a few stone patterns sideways. When almost dry, wash out some of the edges with damp water. Add a little tree wash for the slimy green on the bridge and don't forget the reflections. You can add some more boulders in the water and grass in the foreground with Raw Sienna and Hooker's Green.

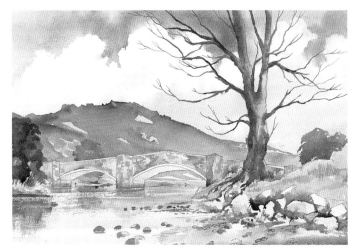

▼ **Stage 7: the shadows**

Mix a grey wash with Burnt Sienna and French Ultramarine and, using a No. 8 brush, paint in the shadows. The light is coming from the right so shade under the bridge arches and stone copings, on the sides of the parapets, the reflections of all these, the large tree trunk and down the bank. Shade the left sides of the boulders and their shadows, the boulders in the river and shadows on the grass bank. When dry, shade in the left-hand side of the large tree and under the bridge arches and parapets. Add some more water to the wash and paint in the ripples in the foreground with little saucer brushstrokes.

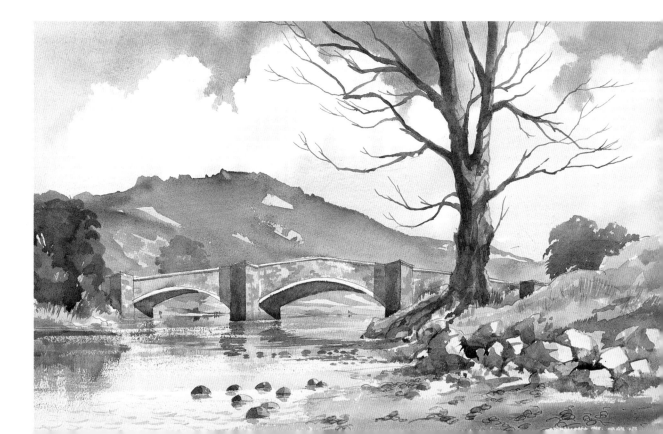

Demo 3: Beach and Cliffs

Here is a subject with a difference. The cliffs at Hunstanton in Norfolk are unique with their distinctive bands of coloured chalk. Be bold when painting this; remember that brushwork can describe almost everything and keeping the painting loose gives it power.

Size: 38 x 56 cm (15 x 22 in) **Paper:** Arches 140 lb Not
Brushes: No. 4 round, No. 6 round, No. 8 round, No. 10 round, No. 4 mop and rigger

Palette:

| Raw Sienna | Cadmium Yellow | Naples Yellow | Burnt Sienna | Burnt Umber | Alizarin Crimson | French Ultramarine | Prussian Blue | Cobalt Blue | Hooker's Green |

◀ Planning stage

Make a simple sketch of the cliffs, rocks and boulders so that you know where to leave your whites. Mark in your horizon. Add a little candle wax to the water in the foreground; this will resist paint and thus create broken white areas. The crests of the waves can be added, using an old rigger with some masking fluid.

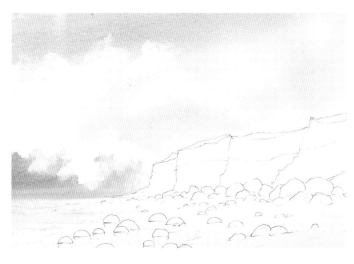

◀ Stage 1: the sky

Mix plenty of Cobalt Blue wash as you don't want to run out. Turn the watercolour upside down and wet the entire sky and along the cliff tops. Add the sky wash, then blot the sky with streaks. Mix a little Alizarin Crimson into the Cobalt Blue, mix well and add to the sky above the horizon. Blot with tissue to create extra cloud shapes. Dry well. Re-wet the entire sky and wash over with Raw Sienna.

◀ Use some candle wax to create broken white areas in the sea area for the waves and foam.

▶ Stage 2: the background

Mix Raw Sienna with Cobalt Blue and paint the sea, making sure the horizon is flat. Turn your board 90 degrees and paint it vertically. Drag the sea up over some of the beach with a damp brush; this will later appear as wet sand. Drop French Ultramarine into the waves.

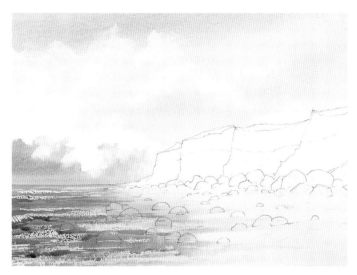

◀ *Add French Ultramarine to the waves under the masking fluid.*

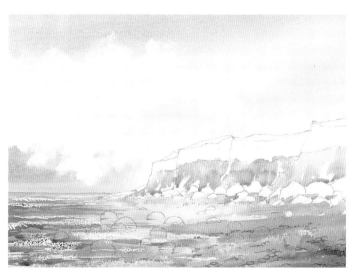

◀ Stage 3: the foreground

Wash in the red chalk with a wash of Raw Sienna and Burnt Sienna. Add a little Burnt Umber wet in wet randomly at the base of the cliffs. Paint the beach with a large mop, using the same wash thinned with water. Add Cadmium Yellow and Burnt Sienna for the nearest beach, then etch in some pebbles and stones. Leave the boulders and cliff top white.

◀ *With the handle of a brush, etch the pebbles and rocks into the wet beach area.*

▶ **Stage 4: the main subject**

Naples Yellow tends to look thick, so mix a thin wash and apply over the cliffs and rocks at their base. Odd bits of white paper can be left for brightness. Mix Raw Sienna with Hooker's Green and paint the cliff-top grass. Use this same wash for the seaweed in the foreground. Add a wash of Burnt Umber and French Ultramarine around the rocks with a damp No. 4 brush.

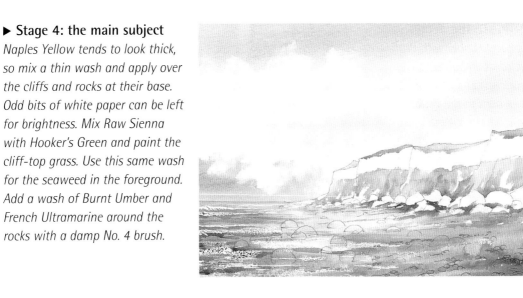

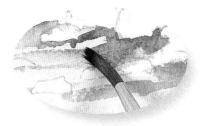

◀ *Add the darks to the rocks with a wash of Burnt Umber and French Ultramarine and tease the paint down onto the beach.*

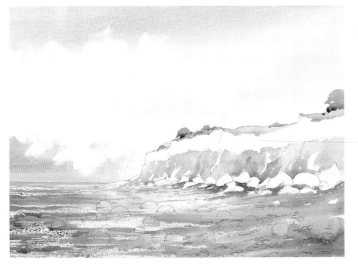

◀ **Stage 5: the trees**

As with most seascapes, the trees are usually minimal. With the edge of a No. 4 brush, add a few shrubs on the clifftop with a wash of Raw Sienna, Hooker's Green and just a touch of French Ultramarine.

▶ Stage 6: the details

Mix Burnt Umber with Prussian Blue for the boulders covered in seaweed. Add a little underneath to the ones in the water, leaving a small light gap. With a damp brush, tease the reflections down. Thin the wash with water to make it lighter and add some simple boulders in the distance. Add one or two gullies in the cliff face, making the brush strokes go with the flow down the cliffs. Add some of this wash to the foreground.

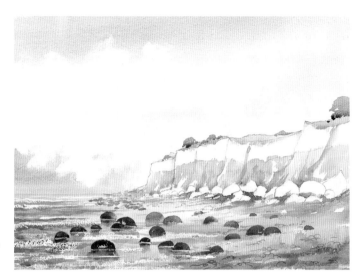

▼ Stage 7: the shadows

When the painting is dry, remove the masking fluid with your finger. Mix Burnt Sienna with French Ultramarine to create a grey – test on a scrap of paper to ensure it is not too dark – and shade in the shadows of the cliffs, boulders and rocks on the beach. Add some shadows underneath the wave crests. Finally, when all this is dry, wet the sky and add a wash of pale Raw Sienna to create the sunny effect.

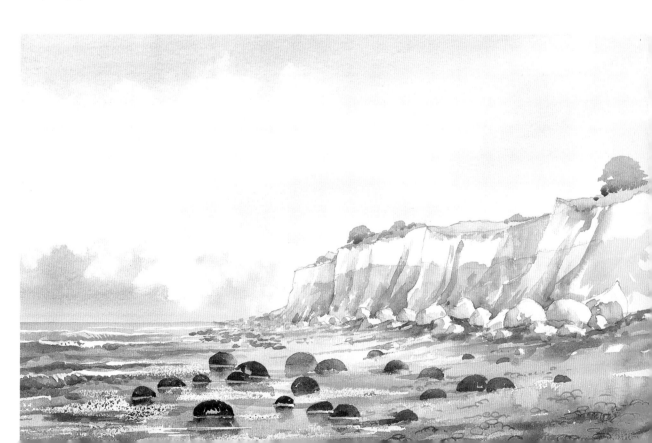

Demo 4: The Crescent

At first glance, this Georgian crescent appears to be a challenging subject. However, by using an elastic band and pin to create the perspective curve (see pages 28–29), it should not be too difficult to draw and paint. The trick is to keep it very simple.

Size: 38 x 56 cm (15 x 22 in) **Paper:** Arches 140 lb Not
Brushes: No. 8 round, No. 6 round, No. 4 mop

Palette:

| Raw Sienna | Yellow Ochre | Naples Yellow | Burnt Sienna | Burnt Umber | French Ultramarine | Prussian Blue | Cobalt Blue | Payne's Grey |

◀ Planning stage
Make a sketch and apply masking fluid with a rigger on the window frames to make painting the glass easier. Mask the outlines of the stone pillars and gate. Let the masking fluid dry thoroughly but avoid using heat to dry the painting. It can make the masking fluid impossible to remove.

▶ Stage 1: the sky
Mix a pale wash of Cobalt Blue and one of French Ultramarine. Turn the painting upside-down to make it easier to paint around rooflines and chimneys. Wet the sky with clean water, wash in the Cobalt Blue with a mop and blot out some simple light. Add the French Ultramarine with a No. 8 brush so as not to overwet it.

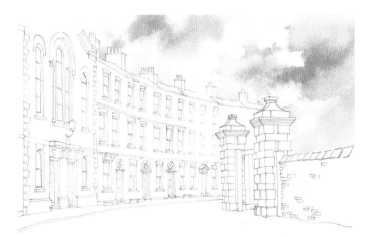

◀ Push the French Ultramarine into the wet paint, then lay it flat to let the colour granulate.

▶ Stage 2: the background

Add simple outlines of distant architecture. Although a lot will disappear behind the tree, it can still be seen through any gaps in the branches. Mix some Raw Sienna with Burnt Sienna for the brickwork as the buildings go off to the right behind the pillars and tree. Keep this pale. Avoid painting any detail; it is simply a colour wash. Add the colour to the chimney stacks and pots.

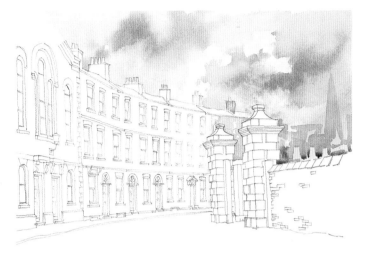

▶ Stage 3: the foreground

Wet the area of road that goes out of sight. Add Raw Sienna to the nearest edge and paint down with a mop for a gentle transition from pale to deeper colour. Wash in the foreground with Yellow Ochre, leaving gaps as light paper. Etch in the brickwork. Add Burnt Sienna as it dries and drag French Ultramarine across the foreground. When dry, wet the distant pavement and wash in the pavement with Cobalt Blue and Burnt Umber. Etch in the slabs.

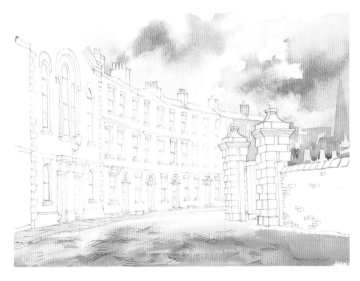

◀ *You can etch in the herringbone brickwork pattern on the wet road with the handle of your brush.*

▶ Stage 4: the main subject

Wash in all the buildings with Raw Sienna. Wash in the pillars with Naples Yellow and add a touch of Burnt Sienna for the pink stone. Starting on the left, add a pale wash of Burnt Sienna over the brickwork, leaving the stone as Raw Sienna. Paint the wall on the right with Burnt Sienna and French Ultramarine and etch in some bricks. Add the roofs with pale Cobalt Blue.

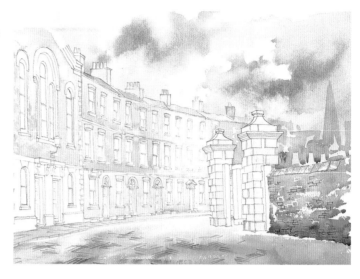

◀ *Etch the brickwork in the wet wall with the handle of your brush.*

▶ Stage 5: the trees

The tree is vital in making the pillars come forward. Using a No. 6 brush on its edge, paint around the edges of the pillars with Yellow Ochre and Prussian Blue. Dry, then darken the wash with French Ultramarine and add more foliage. Dry and add a touch more. Leave a few gaps in the tree for the birds to fly through. Use the same green to add the tree's reflections in the windows.

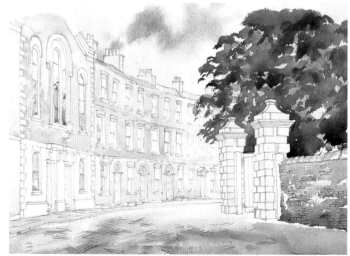

◀ *Add a little green to the window panes in order to create the reflections of the tree and its foliage.*

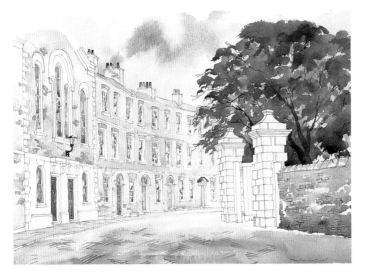

◀ Stage 6: the details

Paint the glass with pale Cobalt Blue, blotting it randomly. Use French Ultramarine with a hint of Burnt Umber for the doors. Etch panels into the first four. Use your door colour to add darks to the windows. Paint the lamp and soot on the chimneys with Payne's Grey. Add Burnt Umber to the window colour and paint in the tree trunk branches. Use Burnt Sienna for the brickwork in the foreground and make random brick patterns.

▼ Stage 7: the shadows

Remove the masking fluid. Organize the shadows into four areas: the buildings; the wall, pillars and tree; shadows across the road; and the dark flash across the foreground. Mix Burnt Sienna and French Ultramarine and start with the buildings, shading the window arches, under gutters and doorways as you work from the left. Keep adding more water to make the shadows paler in the distance. When dry, shade the pillars, wall and tree. Paint the cast shadow across the street and up the walls with a large brush. Mix all the colours you have used, wet the road and add a flash across the immediate foreground.

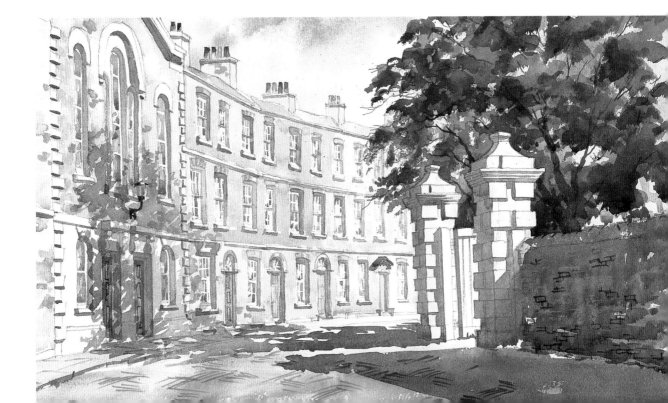

Index